Laurie Britton Newell

# Out of the Ordinary: Spectacular Craft

V&A Publications and the Crafts Council

# Contents

**Foreword**
Rosy Greenlees, Director, Crafts Council
Mark Jones, Director, Victoria and Albert Museum

*Out of the Ordinary: Spectacular Craft* is the first of a series of landmark triennial projects organized by the V&A and Crafts Council. The exhibition marks an important moment in the development of a wide-ranging partnership between the two organizations that spans exhibitions, displays, fairs and residencies and which are all committed to promoting the best of contemporary craft on an international stage.

A number of shared objectives underpin this exhibition. The British craft scene is innovative and should be seen in a global context. The practice of craft is a fluid one, with links to fashion, design, the visual arts and architecture, and makers are continually pushing the boundaries and expectations of what craft is. Exhibitions such as *Out of the Ordinary* are intended to encourage the development of new audiences and engage a younger generation in the debates surrounding craft today. Through this exhibition we want diverse audiences to have the opportunity to see a breadth of work from the UK and beyond, work which explores materiality through a range of skills, techniques and innovations. *Out of the Ordinary* provides an inspiring range of work that will challenge preconceptions and broaden the horizons of craft.

Positioned in the midst of the V&A's wealth of collections, this exhibition initiates a dynamic dialogue between cutting-edge and historic works, and it is appropriate that this ambitious and challenging project is the inaugural exhibition for the newly designed Contemporary Space at the V&A.

Following its showing at the V&A, *Out of the Ordinary* will tour the UK and internationally. Through our partnership we will celebrate craft and enable further debate around the country and the rest of the world. We would like to thank all the staff at the V&A and Crafts Council who have worked together to achieve this project and the many other individuals who have contributed to the delivery of *Out of the Ordinary*. We are particularly grateful to the exhibitors, many of whom have created new commissions and given their time so generously to this major exhibition.

**Introduction**
Laurie Britton Newell

*Out of the Ordinary: Spectacular Craft* is a group exhibition of international artists who use craft to transform everyday subjects and materials into works that are extraordinary. It looks at the ways in which craft is fundamental to many different disciplines: the curatorial approach is premised on the idea that craft is not a separate category but an ingredient, a process, something that has enabled the making of ideas into visible things. It is a celebration of skill, a presentation of spectacular objects that have been meticulously made. And it not only considers what craft *is* but also proposes what it might be.

The artists—Olu Amoda, Annie Cattrell, Susan Collis, Naomi Filmer, Lu Shengzhong, Yoshihiro Suda and Anne Wilson—use very different materials and techniques, but they all make work that is simultaneously familiar and disconcerting. In each case there are recognizable elements that relate to the normal, quotidian and repetitive, but at the same time they demonstrate aspects of the exceptional, illusory and ephemeral. Glenn Adamson's essay *The Spectacle of the Everyday* tackles these oppositional terms and ties the seven artists' work into a theoretical framework. Tanya Harrod provides a subtle history of making in her essay *Technological Enchantment*, introducing new voices to the discussion of craft.

*Out of the Ordinary* also sets out to reveal a behind-the-scenes view of these artists and their working practices, to narrate how and why they do what they do. The photographer Philip Sayer travelled to Beijing, Chicago, Milan, Tokyo and Lagos and around London, to photograph the studios and work spaces of each artist. His pictures show the physical environments where work has been made and capture the details of those spaces, the small things that have been pinned to the walls or collected. The illustrator Lizzie Finn has produced a visual essay of the working processes behind the exhibits, picking out particular tools and manual techniques and hand-stitching them into snap shots of how each artist works: a making of making.

In this way the book presents the progress from the studio to the production of the final work, culminating in the spectacle of the exhibition itself. Interview transcripts give a sense of the artists' views of this process, along with insights into their background and sources of inspiration. Introductions by different writers provide parallel perspectives and multiple strands of thinking about the participants and the themes they address with their work.

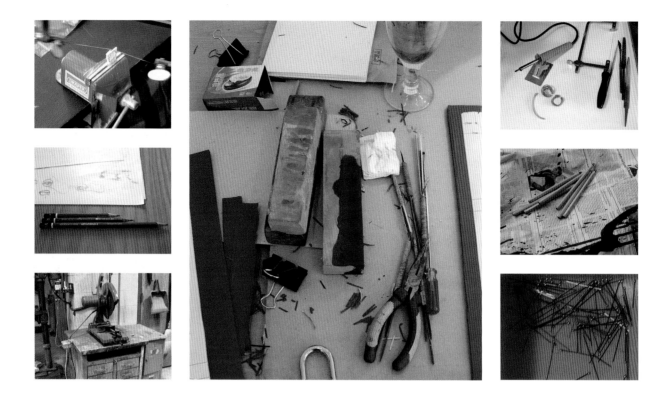

Olu Amoda works with scrap metal from the streets of Lagos. He skilfully welds large-scale structures full of intricate detail—incorporating nails, keys and screwdrivers—to make sculptures, security doors and window grilles that are highly decorative and functional. Anne Wilson also works with found objects, embroidering hair and lace fragments into vast pieces that play with scale and are elaborately detailed. She uses traditional techniques in surprising ways to challenge ideas about the domestic.

Labour is lavished on the most ephemeral of materials in Naomi Filmer's ice and chocolate jewellery, which is crafted by the warmth of its wearer. Highlighting the forgotten spaces of the body—between the toes, or behind the ear—she engages us with the splendour of the human form. The body is also central to the work of Annie Cattrell. She encourages us to reconsider the way in which we experience both what is inside and outside ourselves. Using transparent materials such as glass and resin she gives us a glimpse of what is usually unseen, capturing a moment in time or making visible what is normally felt, be it a passing cloud or a human breath.

Susan Collis makes things that at first glance look out of place in a gallery. Apparently everyday objects, stained and worn, reveal themselves to be arduously crafted interventions, incorporating techniques such as inlay, collage and embroidery. They encourage a reassessment of labour and craft. A similar combination of barely perceptible but breathtaking toil is present in Yoshihiro Suda's work. He carves exquisite, hyper-real plants out of magnolia wood and installs them in unexpected places. These interventions direct our attention towards the beauty in simple things that would otherwise be

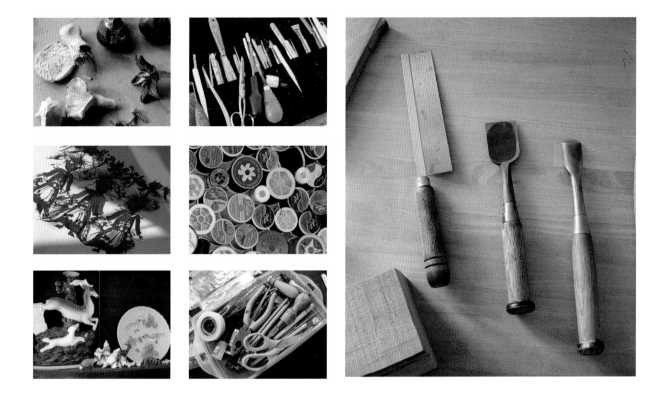

overlooked. Lu Shengzhong creates stunning installations made up of a multitude of painstakingly hand-produced individual pieces using the traditional technique of paper cutting. His work re-interprets the imagery and craftsmanship of Chinese folk art on an unprecedented scale.

This diverse group of artists from different parts of the world do not stand as representatives for whole countries or particular disciplinary fields. Rather they offer us seven personal points of view that interconnect through the following themes:

> **Meticulous Making**—objects that demonstrate scrupulous attention to detail and invite close inspection;

> **Transformation**—the manipulation of materials into new formats, using extremes of scale to create spectacular effects, or the redirection of traditional techniques to achieve unconventional outcomes;

> **The Overlooked Object**—investigations of the familiar, with a twist that injects the ordinary with new insights, unsettling expectations.

What unites all of these works is the unstated conviction that craft has an importance that becomes only more apparent when in extreme situations. By reframing the familiar, the artists presented here show how extraordinary craft can be.

**The Spectacle of the Everyday**
Glenn Adamson

Who would have thought, as recently as five years ago, that by 2007 craft would be the 'in' thing? The signs are everywhere. Teenagers and twenty-somethings form subcultural sewing circles. Leading industrial designers create chairs and lamps using macramé. The Style Network's reality television show *Craft Corner Deathmatch* pits contestants against one another weekly, in duels fought with glue guns. Not since the heyday of the counterculture in the 1960s has craft been so in vogue. The difference is that today, nobody believes that great consequences are in the offing. If craft is interesting again, that's probably because for the first time in a long time, nobody quite knows what to do with it. There is no gentle revolution afoot, to be staged through the making of insistently ethical objects. Craft today, out there in the culture, is entirely amoral. One can make no ethical or social claims one way or another for it. The new attitudes towards craft are not about enacting social change, but about fashion, a delightful play of one style among others. So it's official. Craft has finally been swallowed by the society of the spectacle. The old, long-cherished idea about the handmade was that it acts as a pocket of resistance against the flood of mass-produced commodities. This conviction emerged from the Victorian-era writings of John Ruskin and William Morris, and it structured most twentieth-century discourse on the subject of craft. Like it or not, that idea is now definitively off the table. Craft is submerged fully in the system of exchange, which most people inhabit happily enough, but which some doubters decry as a soulless parade of desire and alienation.

*Out of the Ordinary* is both the result of this unexpected development and an attempt to grapple with it. Though it includes the work of seven artists, it is premised upon a single, simple idea: that craft, having lost its claim to moral virtue, is ripe for reinvestigation. The Victoria and Albert Museum, which has originated the exhibition in collaboration with the British Crafts Council, is no inconsiderable outpost of the spectacle in its own right. It is the prototypical Victorian institution, a phantasmagoria of tourism, celebrity, fashion, history, commodities and visual pleasure. The museum is a surprisingly fitting site for the consideration of kitsch and pop culture, whether this takes the form of a tongue-in-cheek installation by the arch conceptualist Jeff Koons (pl. 1), or an exhibition about the pop star Kylie Minogue. It has also been, for most of its history, the world's flagship of craft reform. Ghosts inhabit the galleries: not only those of Ruskin and Morris, but also Bernard Leach, Soetsu Yanagi and David Pye. So habituated are we to orientating ourselves to the writings of such figures—for or against—that the fact of their complete eclipse comes as something of an unsettling prospect. But, really, who now takes Ruskin's romanticization of the medieval craftsman as anything but thinly disguised anxiety about industrialism? Does anyone fail to realize that Morris was, if an admirable writer, nonetheless an ineffective Utopian with a weakness for aestheticization? Where is the serious potter today who would hold fast to the ideal of the 'unknown craftsman' that Leach and Yanagi championed, given their incuriosity about the real lives of the folk potters they so loved? And even Pye, a professor at the nearby Royal College of Art who vigorously criticized the idealism of Ruskin's writings, and who normally appears a paragon of tough-minded analysis, seems merely nostalgic when he pines for what he calls the 'diversity' of an environment made entirely through craft (the 'workmanship of risk').

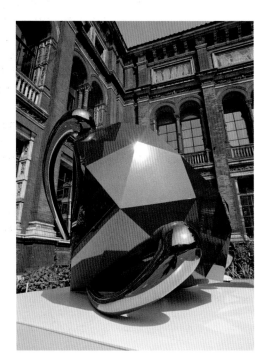

pl. 1
**Jeff Koons**
*Diamond*, 2004
Mirror, polished stainless steel
V&A: 2006BLOG36

All of these great reformist figures have gradually subsided into history. This is not a matter of conscious opposition, but, even more devastatingly, of that tolerant interest which is reserved for the curiosities of bygone days.

The traditional motivation of the craft movement has been to oppose the spectacle through the rhythms of craft work and the quiet virtues of the well-made thing. From this perspective, craft has been seen as exemplifying the everyday, that field of activity that lies beneath the reach of spectacular culture and therefore constitutes a realm of authentic experience. The ideas of the spectacle and the everyday never quite entered the movement's own internal discourse. History's great craft reformers would have formulated the same opposition less precisely, as a matter of the artificial against the genuine, perhaps, or the industrial against the humane. But I would suggest that these terms, spectacle and everyday, usefully connect thinking about craft to broader theories about modern mass culture. As the society of the spectacle has taken shape — Hollywood cinema, television, celebrity magazines and, of course, commodities themselves — Marxist cultural critics have become ever more adept at analyzing its illusory and manipulative ideological effects. Theorists like Roland Barthes and Guy Debord saw commodity culture as constructing false consciousness completely divorced from reality. Thus, Barthes found in plastic an incisive metaphor of the spectacle. Not only is plastic the characteristic medium of endlessly reproduced commodities, Barthes wrote, but its physical properties match the frictionless wish-fulfilment of spectacle itself: 'more than a substance, plastic is the very idea of infinite transformation.'[1] Debord's premise was more abstract, but also more influential. He argued that the spectacle 'manifests itself as an enormous positivity, out of reach and beyond dispute. All it says is: "Everything that appears is good; whatever is good will appear."' For him, mass culture was the final triumph of the commodity fetish, as it had been described by Karl Marx. Production, in the society of the spectacle, was reducible to the 'generalized separation of worker and product [which] has spelled the end of any comprehensive view of the job done'.[2] These writings date from the 1960s, but the decades since have made them seem prescient rather than dated. 'Reality TV' shows, which neither Barthes nor Debord lived to see, are only the latest and most overt example of the society of spectacle.

Stubborn adherence to traditional materials and to the conventions of small-shop production could be seen as a ready antidote to the spectacle. Indeed, as an activity, craft could be said almost to be inseparable from the 'everyday', the field of below-the-radar social practice that Henri Lefebvre had first discussed in his *Critique of Everyday Life* (1947). For Lefebvre, *la vie quotidienne* was unselfconscious, in both a negative and positive sense. It was on the one hand the aspect of culture most deeply penetrated by the spectacle (as when friends banter with one another using advertising slogans they have heard countless times), but on the other, a plane of activity primed for creative rupture. The medieval festival — a celebration of the rhythms of ordinary life, but also an ecstatic, transgressive departure from the social order — was one example that Lefebvre used to convey what he was after: a revolution staged in the least conscious domain of culture.

There was from the first something quixotic about the optimism that Lefebvre invested in the idea of the everyday. It was for him precisely the intuitive, unplanned quality of ordinary life that provided the possibility for 'resistance' to commodification. But how could the everyday then be mobilized to change the status quo? This dilemma induced Debord to develop tactics based on chance operations (such as *dérive*, 'drifting' at random through the city) which might open unexpected doors to authentic everyday experience. Yet good old craft, with its rich subtexts of self-sufficiency, tacit knowledge and steady time, is just as consistent with the Marxist call for an everyday creativity. Indeed, readers of Ruskin and Morris might feel more than a twinge of recognition when reading Lefebvre's words about pre-modern 'peasants and craftspeople', whom he regarded as leading enviably unified lives that are impossible under the alienating conditions of modernity. 'What distinguishes peasant life so profoundly from the life of industrial workers,' he wrote, 'is precisely this inherence of productive activity in their life in its entirety…. Thus up to a point a way of living which strictly did not belong to any one individual, but more to a group of men committed to the ties—and limits—of their community or guild, could be developed.'[3] Lefebvre's idea of authentic experience was itself a sort of 'crafted "work"', which stands in silent and perhaps even unconscious resistance against the artificial 'products' of capitalist enterprise.[4]

For much of the post-World War II period, one could reasonably claim to find in the lives and work of professional craftspeople a practical counterpart to Lefebvre's position. Despite tremendous variety in their opinions, few creative artisans prior to 1980 would have disagreed with David Pye's modest claim that free workmanship is 'something which, though we may not take much notice of it, we need to have'.[5] The conceptual grounding of craft in the everyday experience of making and use was sufficiently established that, as late as the 1980s, it organized the thinking of even the most avant-garde craftspeople. Early in that decade, the Crafts Council asked a group of leading craft artists to select objects for an exhibition entitled *The Maker's Eye*. One participant, the potter Alison Britton, was torn in her curatorial choices between what she called 'poetry' and 'prose'. She was attracted to objects that 'stand back and describe, or represent, themselves', like contemporary artworks, but also to 'vessels or containers that are "ordinary" too, and to me supremely and powerfully so…. To me the most moving things are the ones where I experience in looking at them a *frisson* from both these aspects at once, from both prose and poetry, purpose and commentary.'[6] Britton's words still resonate today, but the situation has nonetheless changed. The prose of the ordinary no longer exerts the gravity it once did. For proof, one need only step into the lobby of the V&A, where a chandelier by the glass artist and impresario Dale Chihuly hangs from the ceiling (pl. 2). An astounding configuration of kitsch sentiment, promotional savvy, mass production and technical prowess was necessary to make this object possible. Chihuly, who has populated museum lobbies the world over with chandeliers like this one, seems to be on a mission to substantiate Barthes' contention that 'the whole world *can* be plasticized'—even in the area of culture that was supposed to provide the stiffest resistance.[7] Craft here appears in a

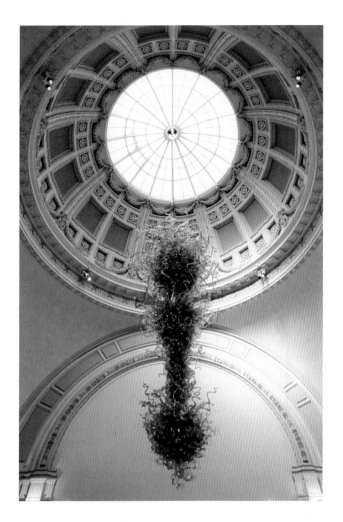

pl. 2
**Dale Chihuly**
V&A Rotunda chandelier, 1999
Glass
V&A: 2006AG3612

new guise, spectacular in every sense of the word. Before the awesome power of such a handwrought commodity, old idealisms about craft can only fall silent.[8]

At the same time that craftspeople like Chihuly were distancing themselves from claims to humble integrity, theoretical optimism regarding the everyday was beginning to seem less like a model of social change than a fantasy of wish fulfilment. The hard-headed sociologist Norbert Elias subjected Lefebvre's concept to withering analysis in 1978, writing that 'as a rule the fashionable concept of everyday life is used in a partisan way, either for or against something which is not everyday life. But what this something is must usually be guessed.'[9] And sure enough, the most significant late entrant into the literature on the everyday, Michel de Certeau's *L'Invention du Quotidien: Arts de Faire* of 1974 (translated into English as *The Practice of Everyday Life*), for all its poetic beauty, reads at times like a text written by a very clever adolescent—an airing of vague discontent and half-dreamed solutions. De Certeau's best-known idea is his distinction between a 'strategy' and a 'tactic'—the former being the act of an authority, such as a government or a corporation, and the latter an act taken without a 'proper' spatial or institutional base. 'Tactics' might include such innocuous but resistant actions as working surreptitiously for

one's own personal benefit on company time, or simply walking idly through a city, free (if only for a few minutes) to invent a unique path through the determinate system of urban space.[10] 'A tactic is an art of the weak,' De Certeau wrote. 'It operates in isolated actions, blow by blow. It takes advantage of "opportunities" and depends on them, being without any base where it could stockpile its winnings.'[11] When De Certeau composed these lines, the revolutionary rhetoric of May 1968 was still in the air, and his fascination with small-scale disruptions in the social fabric seemed credible. Today, though, De Certeau's words are worse than appalling. In an age shadowed by terrorism, his blanket acceptance of illegitimate actions—no matter from what position—reminds us that the theoretical vision of the everyday, even if it is meant to be liberating, can be just as amoral as the totalizing spectacle itself.[12]

Thus, what might have seemed quite a sympathetic argument three decades ago—that craft is a tactical enterprise rooted in the everyday, and therefore a site of genuine resistance to the spectacular, strategic forms of commodity production—has been exposed by the course of events to be a naïve dream. This is not by any means to characterize the idea of the everyday as bankrupt. Like the idea of the spectacle, it continues to be a problematic but useful way to structure thought about culture. However, it is important that the everyday be recognized as an ambiguous terrain. In Ben Highmore's words, 'there is no comfort here for anyone wanting an "object" simply to celebrate or condemn.'[13] Craft, similarly, is a multiple and mobile concept that finds its way into all sorts of disciplines and positions—which, if they are viable, are more likely to be compromised and commercial than resistant or oppositional. What has been lost is the certainty that earlier generations enjoyed. When we contemplate craft practice today, we cannot say that what we see is intrinsically virtuous.

Into this void step the artists in *Out of the Ordinary*. This book is filled with craftsmanship of the highest order, and with the tropes of the everyday: tattered lace, weeds sprouting from cracks in the pavement, a broom propped in a corner, a security gate made from rusted nails.[14] These things are suffused with humility, to be sure, and they speak of the personal language of each of the artists who made them. But they are also presented in a manner that is unapologetically spectacular. The scale of much of the work is so gigantic that it dwarfs the viewer—or so tiny that it incites wonder.[15] Either way, a difference from normal experience is achieved through the exploitation of the gallery space. Forms can leap from one medium (thread) to another (film), in an abandonment of any old-fashioned claims to the authentic properties of certain materials. Even craftsmanship itself has an unaccustomed aspect. It is never earnest or quiet in this exhibition, but instead is employed to create thought-stopping, jaw-dropping 'wow factor'. These artists have mastered a kind of hyper-making that stands apart from the everyday as surely as the feats of digitally powered industry do.[16] Each in their own way, the participants in *Out of the Ordinary* stage that which, from an established theoretical perspective, should never have happened: the spectacle of the everyday.

A brief review of the artists included in the exhibition reveals both the underlying unity of this objective, and the variety of means that can be employed to achieve it. We might begin with the sleights-of-hand fashioned

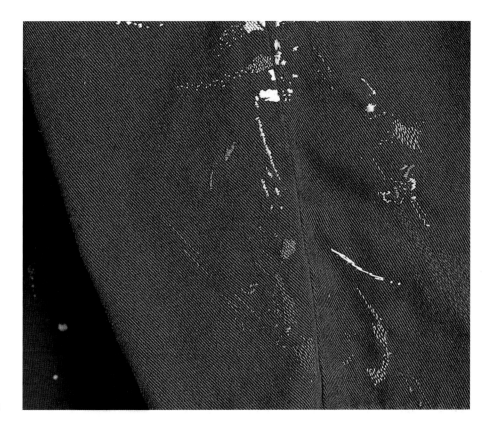

pl. 3
**Susan Collis**
*100% cotton* (detail), 2002
Boiler suit, embroidery thread

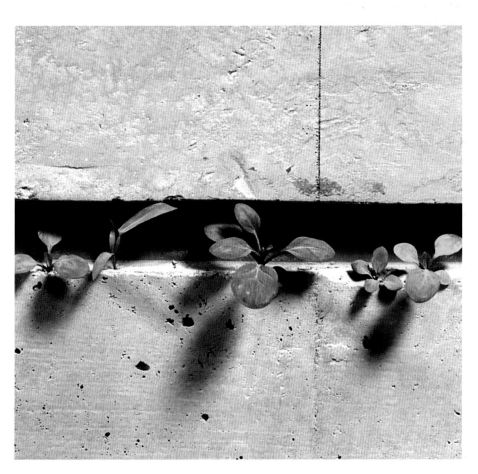

pl. 4
**Yoshihiro Suda**
*Weeds*, 2002
Paint on wood

**The Spectacle of the Everyday**       **Glenn Adamson**       **19**

by Susan Collis, in which spatters of paint prove upon inspection to be laboriously handwrought embroidery or inlay (pl. 3); and with Yoshihiro Suda's fine hand-carved plants, which sprout unwonted from spots in the architectural fabric (pl. 4). Both artists make an overt appeal to the tradition of *trompe l'oeil*. Unlike the more respected genre of still life, which shows us one or more objects as seen by the artist, *trompe l'oeil* pretends to be a wayward fragment of reality. By tradition, it depicts the most ordinary of objects, but in a way that astonishes and deceives; and in this respect, nineteenth-century American *trompe l'oeil* paintings, or even the 300-year-old carvings of Grinling Gibbons (pl. 5) (which Suda's work closely resembles), seem in their weirdness to anticipate the qualities of contemporary art.[17] Works by Collis or Suda, similarly, present us with the 'real'. They do not simply celebrate the everyday; they use it as a foil for the magical. The very banality of their chosen content—drips and weeds—allows the act of presentation to take centre stage. Tremendous skill is here worn so lightly that it nearly disappears from view. But of course, this makes the skill seem all the more impressive. When the viewer has the eureka moment and realizes what went into the making of Suda's hand-carved weeds or Collis's bejewelled stepladder, the fascination of the object is all the more intense because it had previously been overlooked.

pl.5
**Grinling Gibbons**
Carved cravat, *c.*1690
Limewood
V&A: W.181–1928

pl. 6
**Anne Wilson**
*Errant Behaviors,* 2004
Video and sound installation,
edition of eight
Composer: Shaun Decker,
Animator: Cat Stolen, Post-
Production Animator and
Mastering: Daniel Torrente

Collis and Suda are the makers of their works, pure and simple, but Anne Wilson, Naomi Filmer and Annie Cattrell are perhaps more like 'producers'. Both Wilson and Filmer have chosen to contribute films to the exhibition, and both mobilize an array of assistants and other supporting cast. In Wilson's *Errant Behaviors* (pl. 6) thread and lace forms of various descriptions cavort in a heaving, sporadic dance. The stop-motion animation, in which the grinding work of manual rearrangement becomes a fluid movement, is in itself significant: it dramatizes that which is normally (in other films) a purely mechanical separation between the physical reality of the medium and its visual impact. One can almost feel the absent traces of Wilson's dextrous fingers in every shiver and leap of the needles in *Errant Behaviors*, but her labour is entirely effaced by the transformative power of the medium.

Naomi Filmer is even more hands-off, having consigned the manufacture of her works to a well-known British chocolatier. Though hardly alone in her embrace of bought-in skills (what successful contemporary artist wouldn't do the same, given the chance?), her insistence on immediate bodily sensation contrasts starkly with the fundamentally administrative quality of her labour.[18] Filmer is a connoisseur of passing sensations. Her earlier work includes jewellery in

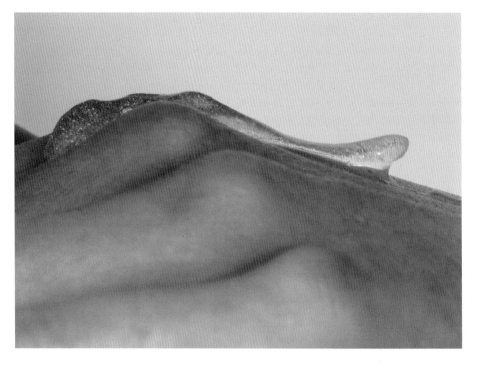

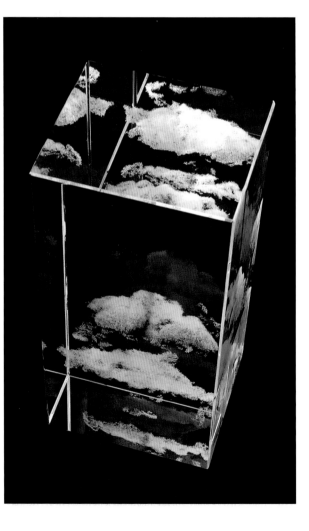

ice, which when applied to the body creates a sequence of experiences: the pain of the initial contact, goosebumps raised on the skin, the slow melting brought on by the body's own heat, the wetness of dripping water, and finally, evaporation, dryness, and the passing of the work into the memory (pl.7). It is telling that she now has an interest in indexing this intimate process to the impersonal and spectacular medium of film. In one recent proposal, she evisions an exhibition in which visitors are given a bit of chocolate wrapped in ice. They are then invited to watch a film timed to the moment-by-moment release of texture and flavour, and eventual disappearance, of what is in their mouth. The experience is both within and without, and the viewer's roles as subject and object briefly merge.

Like Wilson and Filmer, Annie Cattrell has a relatively practical approach to the production of her work. She is more than willing to make things in her own studio, but when necessary she is equally comfortable working with fabricators who possess skills or equipment that she lacks.

This relatively prosaic attitude towards making exists in a certain tension with the literally unearthly qualities of her sculpture. Cattrell's latest endeavour, *Conditions* (pl.8), which involves incising meteorologically precise forms into clear glass using a laser, gives one the heady sensation of towering above a cloud formation. Her attempt to capture and display these most ephemeral and unreachable of objects results in artworks that are beautiful little prisons, luminous blocks that contain but also seal off a magical space. A similarly imaginative leap from reality is evident in *Capacity*, a set of glass lungs fashioned through the more old-school technique of lampworking. It takes a moment to realize that the work is not an exact model of human organs themselves. Rather, it seems to trace the negative space inside the lungs, as if putting on display the blown air that was used in its own creation. Like most of Cattrell's art, *Capacity* attests to the artist's attraction to science, which she sees as offering the sensation, rather than the actuality, of complete knowledge. She presents the everyday in infinite resolution, only to arrive at a delirious new form of magic.

The works of Olu Amoda and Lu Shengzhong act to displace the everyday through a similarly extreme engagement with material particularity. I hope that no eyebrows will be raised when it is suggested that artists from countries like Nigeria and China have mastered the techniques of the spectacle—how could it be otherwise, given the all-pervasive reach of international art fairs such as Frieze in London, Art Basel in Miami, Documenta in Kassel, or the Venice Biennale?[19] In Amoda's iconic assemblages of wrought iron and Shengzhong's cascading sheafs of paper, we see a skilful deployment of the strategies of repetition and scale that flourish in such artificial exhibition environments, and both artists are quite conscious of inhabiting a global art world. Yet they are also deeply invested in the qualities of local terrain. Amoda scavenges his materials from the scrapyards that punctuate the landscape of Lagos, and his forms are an acknowledgement of the unavoidable fact that security, in that city, is at a premium (pl.9). Shengzhong, meanwhile, works entirely in cut paper, 'a folk art tradition that is associated mainly with illiterate peasant women', according to the art historian Wu Hung.[20] The unit repeated *ad infinitum* in Shengzhong's installations, which he calls 'the Little Red

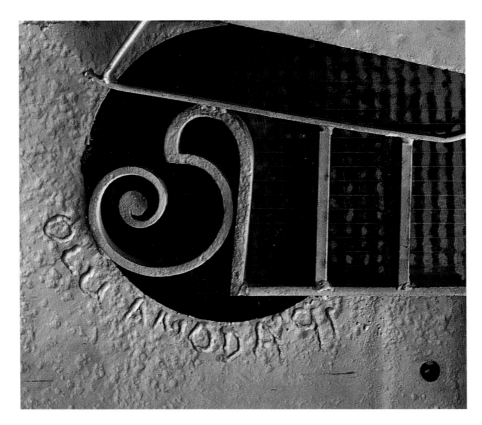

pl. 9
**Olu Amoda**
*Flight Across My Door,* 1992
Steel and glass

Figure', conjures a range of associations specific to China: Buddhist
representations of departed souls; festival decorations; numberless citizens
living under Communism (pl. 10). With their use of geographically specific
visual patois, both artists knowingly inhabit a stereotype: the African
ironworker who fashions objects of brutal beauty from the detritus of a
shattered economy; the scholarly Chinese folklorist who reconstructs the
landscapes of a mystical past. Amoda and Shengzhong dare us to assess
them in these exoticizing, reductive terms. Their works convey the micro-
textures of everyday experience, but also bear witness to the ease with
which those motifs of authenticity are fixed, pigeonholed and exaggerated
for external consumption. There is nothing critical or ironic in this. In
the presence of their works, it is impossible not to miss the raw power
of the caricatures that they inhabit. Equally, it is impossible to miss the
intelligence and self-awareness with which it is framed for our consideration.
As Amoda puts it: 'It must not be forgotten that we live in a world of things,
and our only connection with them is that we know how to manipulate
or consume them.'[21]

For those who are still committed to the precepts of Lefebvre, Debord
and their peers, the spectacularization of everyday forms and content in *Out
of the Ordinary* will seem problematic, to say the least. To begin with, these
theorists were unanimous in their opposition to the museum, particularly
when the architectural shell is a spectacular event in its own right (as in
the Centre Pompidou in Paris, which was to the 1970s what Frank Gehry's
Guggenheim-Bilbao is to the present day).[22] The exhibition space is meant

pl. 10
**Lu Shengzhong**
*The Realm of Great Peace,* 2003
Paper-cut, wood, string, glass

to appear natural and neutral, but of course it is (as Lefebvre insisted) 'produced' through a combination of power, technique and effacement. In the past, avant-garde artists have sought to expose the messy reality that lays behind the pristine museum wall (as in Michael Asher's removals of the divisions between galleries and offices) or its history of collecting (as in the interventions of Fred Wilson).[23] The artists in *Out of the Ordinary,* however, are quite happy to inhabit the white cube of the gallery. More than that, they bind their craftsmanship to the standard operations—deception, production through management, stereotype, repetition, extreme scale, fantasy, fetishization—that might be found in a suburban shopping centre.[24] These works are beautiful, emotionally moving, and technically perfect. They represent new and improved means for the repackaging of the everyday. And so, from a certain perspective, they could be said to have furthered the cause of the spectacle.

But perhaps it's not that simple. The opposition between the spectacle and the everyday is a helpful abstraction, a scheme that delineates the conflicts of post-industrial culture. But as a complete account, it leaves a lot to be desired. As Jonathan Crary (among others) has suggested, 'one can still well ask if the notion of spectacle is the imposition of an illusory unity onto a more heterogenous field.'[25] It is the totalization implied by the dichotomy between the spectacle and the everyday that rings false. This binary opposition obscures a more complicated possibility: a proliferation of conflicting spectacular fictions competing for our attention in an infinite field of mutually incompatible everyday practices,

some inspiring, some mundane, and some reprehensible. Museums exemplify this complex terrain. On the one hand, they are in the entertainment business, and they operate through a combination of decontextualization and display. In this respect they are without doubt engines of spectacle.[26] But museums are also sites where spectacular tendencies are constantly held in tension with countervailing principles of education, accuracy and inclusiveness.

A similar argument could be made regarding the art in *Out of the Ordinary*. Spectacular effects condition the reality of our everyday lives; that much is clear. The question is what should be done about it, now that dreams of revolution have faded away. The unholy creation that is 'the spectacle of the everyday' is one possible response, and one way of achieving it is through craft, which is equally at home in the service of spectacular and everyday effects. Craft is not a field of practice with fixed qualities, as twentieth-century craft reformists tirelessly argued. It easily roots itself in the quotidian, but it can equally inspire unthinking delight. Craft, then, is a form of rhetoric, a way of laying claim to credibility. It is in that respect truly amoral. Nonetheless, *Out of the Ordinary* is a deeply ethical exhibition. I make this statement not on the basis of claims to authentic lifestyle, or some imagined truth based in materiality, function or process. I am thinking, rather, of these seven artists' self-awareness. They know that craft is mainly a matter of persuasiveness, a technique for grabbing attention and holding it. Like any form of rhetoric, it can serve equally to open up thought, or close it down. These artists are to be celebrated for choosing the former option. Theirs is a peculiarly contemporary form of honesty, which involves no self-congratulation—it is nothing more than a recognition of the state of play. The artworks that result from this clarity of vision are not fragments of the spectacular or the everyday; in their thoughtfulness and internal conflict, they are more akin to the many books written about those subjects. Like the writings of Henri Lefebvre or Guy Debord, these artworks create a space for consideration, where opposing qualities are summoned into uneasy co-existence. Lefebvre, who had first formulated the standoff between the spectacle and the everyday, continued to think about the problem throughout his long career. Asked to write an encyclopaedia entry on the subject of the everyday, he found himself expressing continued optimism. *Out of the Ordinary* asks the same rhetorical questions as he did on that occasion: 'Banality? Why should the study of the banal itself be banal? Are not the surreal, the extraordinary, the surprising, even the magical, also part of the real? Why wouldn't the concept of everydayness reveal the extraordinary in the ordinary?'[27] Why not, indeed?

1. Roland Barthes, *Mythologies* (New York, 1972; orig. pub. 1957), p.97.
2. Guy Debord, *The Society of the Spectacle* (New York, 1995; orig. pub. 1967), pp.15, 21.
3. Henri Lefebvre, *Critique of Everyday Life*, second ed., trans. by John Moore (London, 1991; orig. pub. 1958), p.1.
4. Harvey Molotch, 'Lefebvre's Space', *Theory and Society* 22/6 (December, 1993), pp.887–95, the quoted passage on p.889.
5. David Pye, T*he Nature and Art of Workmanship* (Cambridge, 1968), p.36.
6. *The Maker's Eye* (London, Crafts Council exhib. cat., 1981), p.16.
7. Barthes, *Mythologies*, p.99.
8. For more on craft and commodity, see Edward S. Cooke, Jr., 'Wood in the 1980s: Expansion or Commodification?' in *Contemporary Crafts and the Saxe Collection* (Toledo Museum of Art exhib. cat., 1993); Tanya Harrod, T*he Crafts in Britain in the 20th Century* (New Haven/London, 1999), ch.11 *passim*. For a more extensive critique of Dale Chihuly's glass empire, see Mary Douglas, 'Chihuly Sweepstakes', *Artpapers* 16/6 (November/December 1992), pp.6–9.
9. Norbert Elias, 'On the Concept of Everyday Life' (1978), reprinted in Johan Goudsblom and Stephen Mennell, eds., *The Norbert Elias Reader* (Oxford, 1998), p.170.
10. De Certeau here echoes the Situationist practice of the *dérive* ('drift') through urban space. See Guy Debord, 'Theory of the Dérive' (1958), reprinted in Ken Knabb, ed., *Situationist International Anthology* (Berkeley, 1981).
11. Michael de Certeau, *The Practice of Everyday Life*, trans. Steven Rendall (Berkeley, 1984), p.37.
12. For a nuanced discussion placing De Certeau's celebration of 'disorderly conduct' in historical perspective, see Samuel Kinser, 'Everyday Ordinary', *Diacritics* 22/2 (Summer, 1992), pp.70–82. On the discomfort produced by De Certeau's warlike metaphors, see Ben Highmore, *Everyday Life and Cultural Theory: An Introduction* (London, 2002), pp.159–60.
13. Highmore, *Everyday Life and Cultural Theory*, p.174.
14. In this matter of found objects and imagery, the present exhibition resembles a recent project at the Arnolfini in Bristol, which featured (in the words of curator Catsou Roberts) 'fungus, pimples, disembodied eyes, corpses, fish bones, fish heads, excoriated skin, unviewable videos, abandoned clothes, vowless wedding rings, irredeemable coins, obsolete media, frustration, foiled delivery attempts, disassembled bicycles, and dispossessed art works…'. Claire Doherty and Catsou Roberts, *The Silk Purse Procedure* (Bristol, Arnolfini Gallery exhib. cat., 2001), n.p.
15. For a study of such aesthetic effects, see Susan Stewart, *On Longing: Narratives of the Gigantic, the Miniature, the Collection, the Souvenir* (Durham, NC, 1993).
16. For a parallel argument about conspicuous degrees of making, see Johanna Drucker, *Sweet Dreams: Contemporary Art and Complicity* (Chicago, 2005), ch.9.
17. Johanna Drucker, 'Harnett, Haberle, and Peto: Visuality and Artifice among the Proto-Modern Americans', *The Art Bulletin* 74/1 (March, 1992), pp.37–50; David Lubin, *Picturing a Nation: Art and Social Change in Nineteenth-Century America* (New Haven, 1994).
18. See Helen Molesworth, ed., *Work Ethic* (University Park, PA, 2003).
19. On this development see Olu Oguibe and Okwui Enwezor, *Reading the Contemporary: African Art from Theory to the Marketplace* (Cambridge/London, 1999); Wu Hung, ed., *Chinese Art at the Crossroads: Between Past and Future, Between East and West* (Hong Kong, Institute of International Visual Arts exhib cat., 2001).
20. Wu Hung, 'Introduction' in *Lu Shengzhong: First Encounter* (New York, Chambers Fine Art exhib. cat., 2000), p.2.
21. Olu Amoda, *Objects of Art* (Lagos, Signature Gallery exhib. cat., 2005), p.34.
22. Jean Baudrillard, 'The Beaubourg Effect: Implosion and Difference', trans. Rosalind Krauss and Annette Michelson, *October* 20 (Spring, 1982), pp.3–13.
23. See Christian Kravagna, ed., *The Museum as Arena: Institution-Critical Statements by Artists* (Köln, Kunsthaus Bregenz exhib. cat., 2001).
24. See Peter Gibian, 'The Art of Being Off-Center: Shopping Center Spaces and the Spectacles of Consumer Culture' in Gibian, ed., *Mass Culture and Everyday Life* (New York, 1997).
25. Jonathan Crary, 'Spectacle, Attention, Counter-Memory', October 50 (Autumn 1989), pp.96–107, the quoted passage on p.96. See also Harry Harootunian, *History's Disquiet: Modernity, Cultural Practice, and the Question of Everyday Life* (New York, 2000), ch.2.
26. See Hal Foster, 'Contemporary Art and Spectacle' in *Recodings: Art, Spectacle, Cultural Politics* (Seattle, 1985); Johanna Drucker, *Sweet Dreams*.
27. Reprinted as Henri Lefebvre, 'The Everyday and Everydayness', trans. Christine Levich, *Yale French Studies* 73 (1987), pp.7–11, the quoted passage on p.9.

**Technological Enchantment**
Tanya Harrod

How do we understand craft? The artists in *Out of the Ordinary* work on an extended scale. Rather than examining with wonder a discrete object we find ourselves taking in a whole gallery, moving through an environment, at times at a loss to detect or locate the object of our interest. Perhaps it would be more accurate to say that this exhibition is, in part, about craftedness rather than craft. We are invited to concern ourselves with the process of making and this, in turn, leads to reflections on the nature of work, time consumption, the physical rhythms of making, replications and *trompe l'oeil*, technology and virtuosity. The way in which ordinary materials can be made unfamiliar and precious brings to mind a long history of stories and anecdotes that narrate something of the strangeness of making, its hidden secrets and its capacity for enchantment.

Let's begin with virtuosity, a term often linked to a more practical concept, that of technique. The relationship between technique and making is mysterious, prompting thoughts on the education of artists. In schools of art and design, do we require separate departments of painting, sculpture, metalwork, textiles, ceramics and glass, each teaching different techniques? Or should these skills be 'needs-led', to be mastered 'as and when'? In a world of seamlessly interlinked options the idea of a major (albeit self-taught) artist like Francis Bacon devoting a life, day on day, to one genre, the practice of painting, has come to seem unusual, even exotic. More troublingly, perhaps, our capacity to deliver the kind of attention such work strikingly demands has been undermined. At a recent exhibition of the artist Damien Hirst's private collection, a small painting by Bacon (pl. 11) was rendered almost invisible, surrounded as it was by the boisterousness of Hirst's contemporaries.[1] Why should that be?

pl. 11
**Francis Bacon**
*Untitled* (version of the right
hand panel for *Three Studies
for the Base of a Crucifixion,*
Tate Britain, 1944) *c.*1945

The problem has been addressed by the sculptor Phyllida Barlow
(pl. 12). As a student in the early 1960s she was taught clay modelling,
casting, plaster modelling, the making of armatures and construction and
assemblage in wood and metal. But now she finds she has 'an uneasy and
very problematic relationship with making'.[2] In part this is because the
world 'is stuffed with fascinating things. We are competing with
materialism that is on such a gigantic scale. There is a giant global industry
of objects and how does one compete with that?'[3] In her essay *The Hatred
of the Object* (1995) Barlow divides the world of things into two
categories—hot and cold. There is the 'hot' object, 'processed through
the private and personal rituals of making' that can 'repulse through its
desperate need to attract'. Then there are other kinds of objects that demand
our attention and love—'cold' objects that have been industrially designed and
manufactured. They work on our emotions, often seductively and pleasurably,
but they too can seem repellent when we consider their rapid obsolescence and
the polluting materials from which they are made. Barlow goes on to argue
that 'cold' objects have invaded the world of art, as artists turn to fabricators
or re-present existing objects. There is no need to engage physically: 'it can all
happen elsewhere'[4]—often employing industrial processes.

The tension between the idea of the maker, battling with materials,
and the cool conceptualist, on an extended research project, using found
objects or sending ideas to a fabricator, has a longer history than we might
imagine. It was intrinsic to Renaissance aesthetic debates over the relative
merits of painting, sculpture, architecture and poetry—the *paragone.* Some
of the most heated discussions set painting against sculpture. For Da Vinci
painting was superior because it was more intellectually demanding—'the
sculptor's work entails greater physical effort and the painter's greater
mental effort'.[5] The painter studied science and mathematics while the

sculptor worked mechanically, wielding a chisel and a hammer. Paradoxically it is the genre of painting that might today seem a laborious occupation as compared with the elegant urban wanderings of a sculptor like Richard Wentworth, capable of seeing value in an everyday encounter between a throwaway cup and a cast-iron railing or in a pair of galvanized buckets wrapped in brown paper bags.

Virtuosity can take many forms. In their remarkable study *Legend, Myth and Magic in the Image of the Artist: A Historical Experiment* Ernst Kris and Otto Kurz scanned ancient and early modern literature for stories about artists. They rehabilitated the anecdote from the condescension of art history and demonstrated how biographical narrative can neatly condense ideas about creativity.[6] Kris and Kurz did not venture much beyond the seventeenth century in their survey but one recurring motif was that of the artist as a species of magician whose work could deceive and astonish through its mimetic power—as when sparrows pecked at grapes painted by Xeuxis or passers-by mistook Titian's portrait of Paul III (placed on a window ledge to dry) for the living Pope. Kris and Kurz suggest that part of the allure of art derives from a technical virtuosity that breathes life into objects, making the artist an *alter deus*.[7]

The idea that art can fruitfully be viewed as magical technology was explored by the late Alfred Gell in his quest for an anthropological theory of art that by-passed art-world aesthetics—what he called 'methodological philistinism'.[8] His approach went beyond mimesis, opening up the visual field to include the impact of Trobriand Islanders' prow-boards and the wonder experienced by Gell aged eleven when confronted by a matchstick model of Salisbury Cathedral, as well as an appreciation of a catholic range of Western art. Gell was a great admirer of Marcel Duchamp, writing perceptively about his transformational artistic powers. Melanesians, schoolboys and art-loving anthropologists, he argued, all respond to 'the enchantment of technology', 'the power that technical processes have of casting a spell over us so that we see the real world in an enchanted form'.[9] Nonetheless, Gell understood the position of the contemporary artist to be a difficult one: 'Technique is supposed to be dull and mechanical, actually opposed to true creativity and authentic values of the kind that true

pl. 12
**Phyllida Barlow**
*Untititled*, 2002
Paint, paper, wood, concrete, foam, tape

art is supposed to represent.'[10] If technology has a magical dimension today, he argued, it is in pursuit of the chimera of ever-expanding industrial production, the present-day equivalent of the nineteenth-century manufacturer Andrew Ure's dream of autogenesis—a factory of machines that produce without workers.[11]

Gell published his essay 'The Technology of Enchantment' in 1992. Since then the ecological and human costs of the productivity chimera are increasingly recognized and feared. One artistic response to a world so full of goods has been to cannibalize, recycle and collage existing objects—or to cease to make altogether and instead curate or re-order public collections.[12] Meanwhile the idea of craft has floated up as an area of generalized interest. Take the writings of the American sociologist Richard Sennett. *The Corrosion of Character: The Personal Consequences of Work in the New Capitalism* (1998) and *Respect: The Formation of Character in an Age of Inequality* (2003) seize on craft as an alternative to the endless self-reflexiveness of contemporary life. But of course self-reflexiveness, as Sennett points out, compensates for post-industrial working practices based on here-and-now organization and on short-term contracts that damage individual dignity, making it harder to construct life stories with a sense of cumulative achievement. Skills won through long experience appear to count for nothing. Even when engaged on production (as opposed to the service industries), work is often illegible to the workforce—they can neither mend the machines they use nor fully understand the processes of production. Think of the isostatic dust pressing of plates at advanced ceramics factories! As a result identities are eroded.

In any case, as Sennett argues, we live in a world that singles out comparatively few for recognition and where we are endlessly being assessed and judged. His solution is perhaps surprising: 'The best protection I'm able to imagine against the evils of invidious comparison is the experience of the ability I've called craftwork and the reason for this is simple. Comparisons, ratings, and testings are deflected from other people into the self; one sets the critical standard internally. Craftwork certainly does not banish invidious comparison to the work of others; it does refocus a person's energies, however, in getting the act right in itself, for oneself. The craftsman can sustain his or her self-respect in an unequal world.'[13] When Sennett sees craft as a protection he is thinking of his childhood in a deprived area of Chicago when he got solace and a sense of worth from playing and practising the cello—craft as performance.

The turn to craft as an act 'right in itself' is, however, not always consoling. The overheated catalogue introduction to the Saatchi Gallery's exhibition *New Labour* in 2001 celebrated 'laborious physical involvement' and the democracy of craft—'anyone can learn these crafts'. The crafts employed in Grayson Perry's ceramics, Enrico David's 'gesturing abstract patterns with a router on MDF' and Michael Raedecker's paintings are DIY and homely—evening class pottery, 'grade 9 woodworking skills', 'granny-craft stitching', 'knitting and darning'.[14] The subject matter was far from reassuring, however, and part of the impact depended upon a disjunction between the medium and the message—between vases and child murder, between DIY shelving systems and home-made pornographic movies, between cosy stitching and the emptiness and anomie of modern living.

We might argue that in this instance craft is employed ironically. Form and context are incongruous.

Then again, in 2004 the Prince Klaus Fund in Denmark published a book of essays entitled *The Future is Handmade*, which further underlined how contingent are our ideas about craft. An essay by the art historian Iftikhar Dadi argued that cheap toys made in Pakistan using recycled plastic and hand-operated plastic-moulding machines can be viewed as a species of urban craft.[15] Fifty or even twenty years ago a plastic toy was craft's antithesis. But these objects seem nostalgic in their crude facture—the all-too-visible seams and hand-painting, for instance (pl. 13). They remind us of the homogenizing effects of globalization but at the same time of the local—of uneven development in South Asia with its transnational corporations and its unplanned urban slums and informal networks of production. These modest examples of backstreet manufacturing also remind us of the agency of the local, of the way people keep on making, keep on being inventive, keep on keeping on.

pl. 13
Toy rickshaw, 2004
Plastic and rubber

Although technique is seen as central to the idea of craft (indeed is often seen as its essential core) it has had an uneasy relationship with the subtle aesthetics of the unevenly chronicled and conceptualized twentieth-century craft movement. After World War I, the nineteenth-century Arts and Crafts Movement splintered into a series of individuated studio-based disciplines. In England early twentieth-century craft (particularly in the fields of textiles and ceramics) was central to an insular eclectic modernism. Technique came to seem at best an irrelevance, at worst a hindrance. This was particularly marked in the field of studio pottery where apparently appropriate skills—accurate fast throwing, a firm grasp of ceramic science and efficient, successful firings—were no guarantee of aesthetic success. What was sought was a kind of embodied tenderness within the world of things. Thus a figure like Michael Cardew embraced chaotic experiments with clays and glazes, unsatisfactory potter's wheels and long, often disastrous firings to produce objects of great resonance (pl. 14).[16]

Craft can bestow dignity upon individuals, can be employed knowingly and ironically and can be used to describe plastic toys as well

pl. 14
**Michael Cardew**
*Plate,* 1962
Stoneware, combed and
wired decoration, made in
Abuja, Nigeria

as neo-primitivist modernist textiles and studio ceramics. Craft is also a
technology that operates as a critique of the present, in particular of the
chimera of ever-expanding industrial production. Paradoxically, it can also
be found hidden within industrial and post-industrial production—with
the Sheffield steelworker who had twenty-six criteria for judging when
steel was ready for cooling,[17] or in the numerous tacit skills associated with
computing. All this suggests that craft is a word that is almost too pregnant
with meaning. This is both a strength and a weakness. It certainly allows
us to associate craft with virtuoso technology of the kind that causes us, as
Gell argues, to 'see the real world in enchanted form'. *Out of the Ordinary,*
we could argue, represents a particular curatorial vision of 'craft' that is
embodied in virtuosity, a handmade technological sublime.

For instance, the Chinese artist Lu Shengzhong and the Japanese
artist Yoshihiro Suda employ culturally specific pre-industrial technologies—
the folk art of paper cutting and fine block carving in wood. To work
traditionally in China is not necessarily a conservative decision. At the
2006 Shanghai Biennale there were plenty of threnodic tributes to
craftsmanship by young Chinese artists. The strange Mindicraft group
(Zhang Beiru, Ruan Jiewang and Mak Yee Fun) seek to honour Ming and
Quing craft skills. Yan Jun re-creates traditional Chinese furniture out
of disused heating pipes. Ling Shaoji's video, photography and timber
installation *Essence of Wood* mourns the ongoing demolition of vernacular
architecture. Meanwhile another artist, Liu Jianhua, underlines the reality
of present-day China. His piece piles up 30,000 low-cost objects made in
Yiwu. This is a manufacturing town unfamiliar, I would guess, to most of
us, but Yiwu daily exports 1000 containers to the shopping malls of the
West.[18] The presence of so many works that comment on lost skills and
working practices suggest that China is developing a twenty-first-century
Arts and Crafts Movement—a turn to painstaking handwork as a response
to destructive modernization—that is just as radical as its nineteenth-
century predecessor.

Both Lu Shengzhong and Yoshihiro Suda have adopted pre-industrial
rhythms of working—chanting while cutting paper, emptying the mind,
consciously going against the grain of the hyper-reality of the present.
They both generate 'artists' anecdotes' of the kind valued by Kris and
Kurz. Lu Shengzhong recalls a life-changing encounter with a folk artist

in Western China.[19] Yoshihiro Suda had a moment of epiphany when almost by chance he embarked on an exercise in carving in his first year at art school. Like a Lysippus or a Giotto Suda needed no teacher.[20] And like many of the artists discussed by Kris and Kurz, he has an apparently magical mimetic skill that works to unsettle the eye of the spectator.

Mimesis, replication and *trompe l'oeil* are also explored in *Out of the Ordinary* by two British artists, Susan Collis and Annie Cattrell. As with Suda, theirs is not the painterly deception of Xeuxis but something more unnerving—the re-creation of the thing itself. We might reflect that craft and replication are often linked. In R.G. Collingwood's famous aesthetically led discussion of the difference between art and craft he argued that the craft object will always replicate, be part of a series, and be planned in advance.[21] For Collingwood this meant that craft was a second-order activity.

But replication, when detached from industrial manufacture, has more complex connotations—of trickery, but also of the pursuit of beauty. As Elaine Scarry explains, 'beauty brings copies of itself into being. It makes us draw it, take photographs of it, or describe it to other people. Sometimes it gives rise to exact replications and other times to resemblances.'[22] Hallucinatory accurate replications (the thing itself)—Yoshihiro Suda's weeds and flowers, Annie Cattrell's *Capacity* (a rendering of human lungs in glass), and Susan Collis's deceptive *Spuren* or traces on clothes and objects—are inherently troubling, partly because of their perfection. They invert 'the expected hierarchy of original over copy'.[23] In the case of Naomi Filmer, the thing itself has an even more unstable existence, being made of ice or chocolate or presented in lenticular form—as a hologram. Her work embraces the ephemeral and the fast-vanishing, with jewellery, for instance, that literally, and punningly, wears itself out. The highly crafted artifice embodied in these objects forces us to confront the world anew, even to doubt our place in the world.

Anatomical drawings and models have a long history in which science and art overlap, ranging from Da Vinci's diagrammatic researches to actual body parts preserved in formaldehyde—originals presented as instructional copies. Annie Cattrell has made body parts and functions visible in various ways—through the handwork of glass-blowing and lampwork used in *Capacity*[24] but also through using magnetic resonance imaging (MRI) scans translated into files that can be printed out on a rapid prototyping machine. Rapid prototyping, in its various forms, has unexpectedly poetic qualities. *Centred*, Cattrell's extraordinary SLS (selective laser sintering) rendering of her own heart, demonstrates the creative slippage between the perfection of the digital file and the translation into production, where the algorithm meets the material.[25] There is a sense of Victorian after-life, for these rapid prototyping machines remind us of nineteenth-century technologies like electrotyping. But their slow pace of replication (not so rapid after all) appears to mimic a ghostly handmade procedure, an autogenic craft.

A similar sense of a ghostly handmade runs through the work of Anne Wilson. In her video installation *Errant Behaviors* she metaphorically and literally unravels textiles to explore a tangle of subversive and unsettling encounters. Her textile installations similarly separate out tools, materials and processes to create haunting large-scale topologies that

appear to map an unfamiliar culture with its own busy, unfathomable rationality. Lace has powerful associations—not least in the context of upper-class philanthropy led by women for women at the end of the nineteenth century. Wilson thus employs a set of technologies that might be called gynotechnics—'a technical system that produces ideas about women'.[26]

Craft, as a word, begins to drift and perhaps we need to return to the shore. In Nigeria craft comes with a weight of history. It remains intrinsic—everywhere you drive in Nigeria men and women are making things, right there, in open-air workshops, on the red earth of the roadside. But 'craft' was also artificially encouraged before independence as part of the dreaming of a colonial administration that forced the glamour of backwardness upon the colonized. There were, for example, Cardew's experiments with stoneware pottery, as an evolutionary bridge between the indigenous and the industrial. Today, thankfully, the handwork is found where it is needed—above all in a multitude of furniture and metal workshops, embracing every conceivable design vocabulary.

The artist Olu Amoda has seized the moment. His large workshop in Lagos is filled with scrap metal that is recycled into sculpture and into doors and grilles. In some ways the functional side of his practice resembles that of the young Vulcans—Tom Dixon, Ron Arad and Andre Dubreuil—whose 'salvage baroque' metal furniture took London by storm in the 1980s.[27] But his grilles and doors—'Windows of Dreams' and 'Doors of Paradise'—are more than ordinarily functional in a country where the rule of law is fragile and armed robbers show little mercy. Not that Nigeria's current social and political problems are the whole story. As Nkiru Nzegwu points out, Amoda's work links back to an ancient West African concern with function—where 'the superbly carved *aafin* (palace) caryatids were verandah posts, the beautifully designed bas-relief wooden panels were doors, and the stylised elegant iron birds on *Orise* Osanyins' staffs (pl. 15) announced the *orisa's ase* (the divinity's life force)'.[28] The enchantment of technology has real meaning in Nigeria. It seems a good place to moor the craft.

pl. 15
Yoruba bird staff, Osanyin cult,
Nigeria, twentieth century
Forged iron and found materials

**Out of the Ordinary: Spectacular Craft**

1. Serpentine Gallery, 'In the darkest hour there may be light': Works from Damien Hirst's murderme collection, 25 November 2006–28 January 2007.

2. Phyllida Barlow, Mark Godfrey, Alison Wilding, Jon Wood, Objects For... And Other Things: Phyllida Barlow (London, 2004), p.122.

3. Ibid., p.66.

4. Ibid., p.184.

5. J.P. Richter (ed.), The Literary Works of Leonardo da Vinci (Oxford, 1939; orig. pub. 1883), vol.1, p.91.

6. Ernst Kris and Otto Kurz, Legend, Myth and Magic in the Image of the Artist: A Historical Experiment (New Haven/London,1979; orig. pub. 1934). See also Nina Lübbren, Rural Artists' Colonies in Europe 1870–1910 (Manchester, 2001), p.22.

7. 'A second god'; ibid., p.61.

8. Alfred Gell, 'The Technology of Enchantment and the Enchantment of Technology', in his The Art of Anthropology: Essays and Diagrams (London, 1999), p.161. Thanks to Sophie Heath for her discussion of this article.

9. Ibid., p.163.

10. Ibid., p.185, note 3.

11. Steve Edwards, 'Factory and Fantasy in Andrew Ure', Journal of Design History, vol.14, no.1 (2001), pp.17–33, see especially p.26.

12. See Neil Cummings and Marysia Lewandowska, The Value of Things (Basel, 2000) and Capital: A project by Neil Cummings and Marysia Lewandowska (London, 2001).

13. Richard Sennett, Respect: The Formation of Character in an Age of Inequality (London, 2003), pp.98–9.

14. Patricia Ellis, New Labour (London, Saatchi Gallery exhib. cat., 2001).

15. Iftikhar Dadi, 'Plastic Toys and "Urban-Craft" in South Asia: Pakistan' in The Future is Handmade: The Survival and Innovation of Crafts, Prince Klaus Fund Journal no.10 (2003).

16. Tanya Harrod, The Crafts in Britain in the 20th Century (New Haven/London, 1999), p.258.

17. Arnold Pacey, Meaning in Technology (Cambridge, Massachusetts/London, 1999), p.73.

18. Fang Zengian and Xu Jiang (eds), 6th Shanghai Biennale (Shanghai, 2006).

19. First Encounter: Lu Shengzhong (New York, Chambers Fine Art exhib. cat., 2000), p.5.

20. Interview/Yoshihiro Suda Yuka Uematsu (ed.), Yoshihiro Suda (Marugame Genichiro—Inokuma Museum of Contemporary Art / The MIMOCA Foundation exhib. cat., 2006), p.93.

21. R.G. Collingwood, The Principles of Art (Oxford, 1938), pp.15–29.

22. Elaine Scarry, On Beauty and Being Just (Princeton/Oxford, 1999) p.3.

23. Nick Groom, 'Original Copies. Counterfeit Forgeries', Critical Quarterly, vol.43, no.2 (Summer, 2007), p.9. See also Norman Bryson, Looking at the Overlooked: Four Essays on Still-Life Painting, London, 1990, pp.140–45.

24. For a good scientific overview see Cathy Gere, 'Thought in a vat: thinking through Annie Cattrell', Studies in the History and Philosophy of Biological and Biomedical Sciences, vol.35C, no.2 (June 2004), pp.415–36.

25. Tanya Harrod, Otherwise unobtainable: the applied arts and the politics and poetics of digital technology, paper given at the symposium Pixel Raiders: Applied Artists and Digital Technologies, unpublished, 2002.

26. Francesca Bray, Technology and Gender: Fabrics of Power in Late Imperial China (Berkeley/Los Angeles, 1997), p.4.

27. City Steel: Contemporary Metal Furniture (London, Crafts Council exhib. cat., 1991).

28. Nkiru Nzegwu, 'Riding the Spirit of Ogun: the art of Olu Amoda', NKa: Journal of Contemporary African Art, vol.1, no.1 (Fall/Winter 1994), pp.8–15; see www.africaresource.com/exh/amoda/exogu.htm.

OLU AMODA

Annie Cattrell

SUSAN COLLIS

Naomi Filmer

Lu Shengzhong

YOSHIHIRO SUDA

Anne Wilson

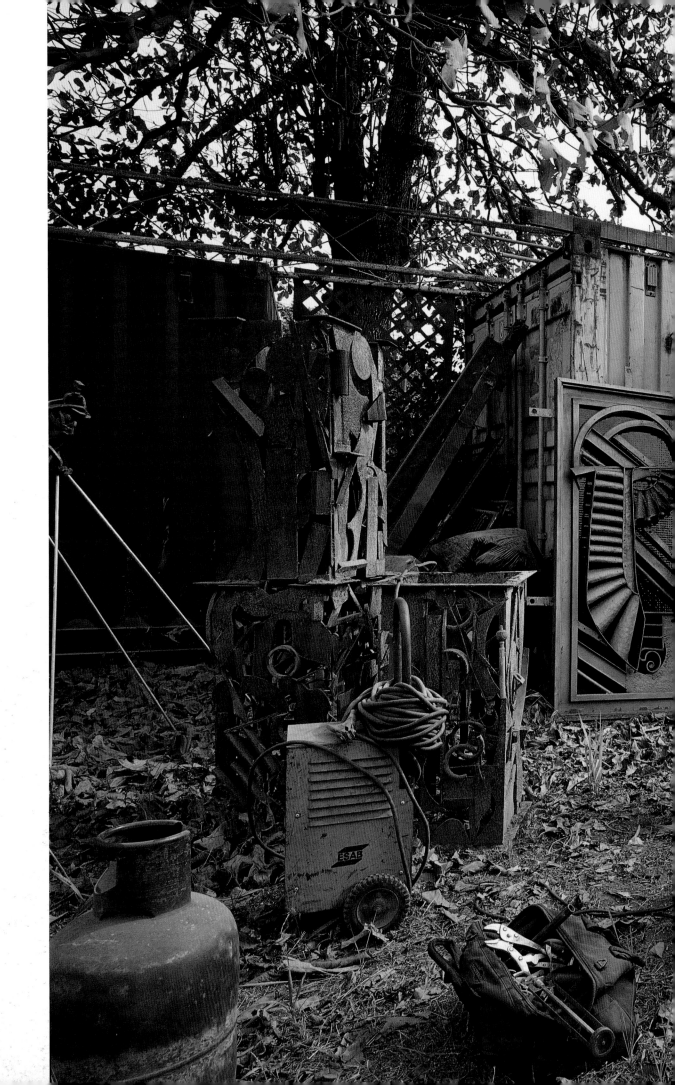

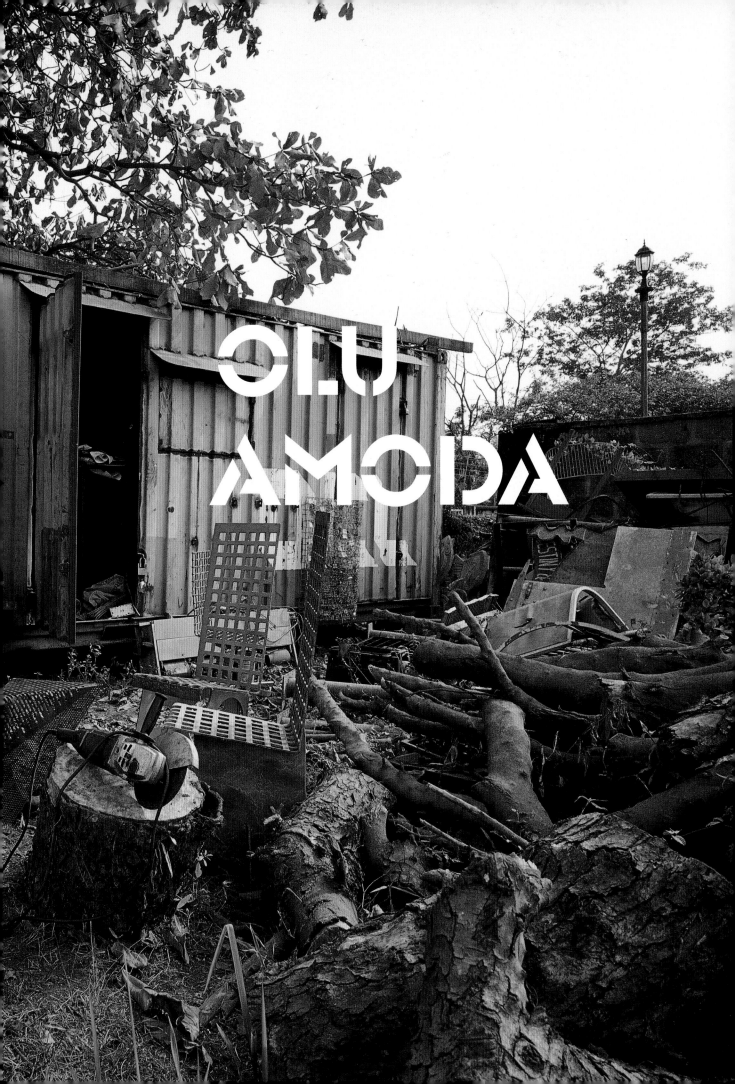

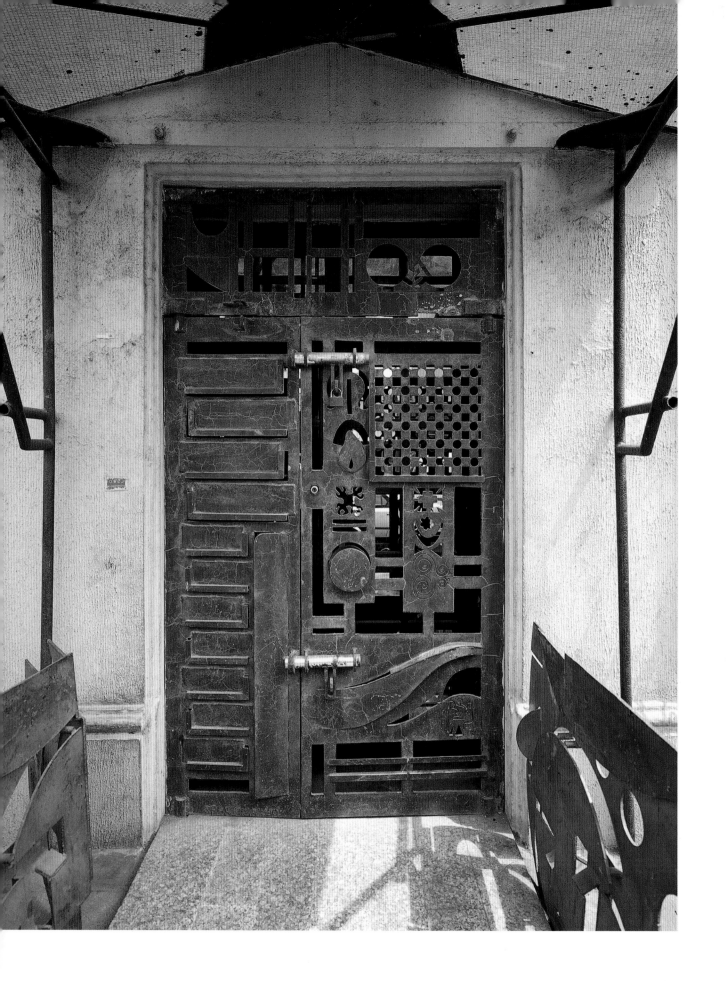

Out of the Ordinary: Spectacular Craft

## Crime and the Index
David T. Doris

If there is one thought that Nigerians today seem to hold in common, and which could constitute the core moment of any 'Nigerian' identity, it might be this: Nigeria is a nation of unsurpassed natural and human resources that has been run into the ground by the criminals who rule it. Nigerians generally distrust government officials and police, regarding them respectively as thieves and armed robbers. The distrust is not unfounded. Corruption is endemic in Nigeria, and grand-scale thievery has become a kind of national institution—no longer a mere suspension or overturning of the laws that regulate everyday life, but a tacit component of the Law itself. Recently there have been a few widely publicized federal efforts to stem corruption at high levels, but Nigerians aren't holding their collective breath. They have come to expect nothing from their government, because that is usually what they get.

It comes as no surprise that in Nigeria the rate of everyday crimes such as theft, burglary, fraud and armed robbery has increased dramatically during the last couple of decades. Ironically, this has been concurrent with an upsurge of religious fervour, as millions flock to churches whose priests enjoin them not to steal, to love neighbours, to fear God, and so forth. But in an atmosphere of seemingly perpetual instability, prayerful words are one thing, and honest actions quite another. For some, crime is the only means available for making a decent living, or at least for getting by *today*, and no one knows precisely who will be stealing what from whom at any given time. A justifiable paranoia—or let us say a profound wariness of others' intentions—pervades social life in Nigerian cities, and the protection of personal property is the order of the day. 'It's hard to get,' a young professional in the southwest once told me, 'it's hard to keep, and everyone wants to take it away from you.'

The built landscapes in Nigerian cities bear witness to the ubiquity of this ordinary dread. In wealthier urban districts, compounds often are enclosed by high, thick cinder-block walls pierced by massive gates of iron or steel, and usually topped with materials intended to cut the flesh of intruders: barbed wire, razor wire, shards of glass from broken windows or shattered soft drink bottles. Inside are more defensive armaments: padlocks, steel doors, iron grates over windows. Effectively, these homes have become fortresses, designed to keep others out; but they also are prisons, confining residents within the walls of their own worst fears. In many cases, and not without irony, the most fortified compounds belong to those wealthy people who have the most to hide.

Previous spread
Olu Amoda's studio in
Lagos, Nigeria, 2007

Opposite
**Olu Amoda**
*Dynamic Portfolio
Entrance Door,* 1998
Steel

Not far from the hectic sprawl of Lagos's Yaba district, on the campus of the Yaba College of Technology, the sculptor Olu Amoda fashions burglarproof gates, doors and window grates out of steel and iron. He calls these creations 'Doors of Paradise' and 'Windows of Dreams', a unifying brand name inspired by Lorenzo Ghiberti's Florence Baptistery doors of 1452, called by Michelangelo 'The Gates of Paradise'. The names alone reveal something of Amoda's multi-faceted ambition: they ennoble the objects, setting their brute functionality within a distinctly international art historical tradition. And with a whiff of spirituality that echoes both Christianity and Islam (yet commits to neither), the names are intended to dispel the anxiety that motivates Nigerian property owners to commission such things in the first place. This is sumptuary art, brilliantly conceived and custom-designed; and it is functional stuff for preventing crisis, built strongly and well.

Whether Amoda creates his works to protect properties or to be shown in galleries—and were it lucrative in Nigeria, he would no doubt choose the latter—he intends them to be instructive. The lessons are not obvious, but neither is it necessary to spend time scouring the works for, say, evidence of Christian parables or 'African' symbolism. And while many of Amoda's pieces comment critically and directly on the sad state of Nigerian public affairs, their real didactic import lies elsewhere. However figurative or abstract a work's imagery may be, however direct or oblique its narrative relation to the world, it is in, on and through materials themselves that Amoda locates and reveals his larger concerns, transforming matter into metaphor.

Forgotten scraps of iron and steel gleaned from junkyards, roadsides, or wherever—for Amoda, these things vibrate with invisible intentionalities, the residual energies of past users. Both on and below the surface, an old piece of metal retains the traces of the human beings who created it, used it, cared for it, damaged it, discarded it. Such an object is an *index*: it refers us to its own history, and to the absent actors who remain present in its substance. When that object is brought together with others in a single work, its history becomes collectivized, transmuted by its refractory exchanges with those other objects. As a constituent part of a functioning work of art, each piece contributes not only to a wider, more variegated history, but also to a sturdier, more unified and harmonious future. And in making that contribution, each object—however scarred, rusted or wounded it may be—is redeemed.

To encounter Amoda's work, then, is to be addressed by a miniature model of a beautiful, reciprocative society, a poetic allegory of human possibility born of ceaseless frustration and hope, and touched by care. It also is to be confronted by a sheer mass of unyielding metal armour, built to separate people from each other. The pitiless functionality and dreamy poetry of Amoda's works do not negate each other; the pairing is neither absurd nor incongruous. In Nigerian cities, dreams must reckon with a stubborn reality, and with the stubborn men and women whose greed plagues it. Olu Amoda's works face that reality squarely, stubbornly, in a ruthlessly practical way that also posits, on the visible face and at the vibrating core, a dream. Until the day all Nigerians become Good, each guarding the welfare of the many, a Nigerian Paradise, however gorgeous its portals, must also be a Very Secure Place. But then, that's probably true everywhere.

**Olu Amoda**
*Mortherlan Piano Gates*, 1997
Steel

**Out of the Ordinary: Spectacular Craft**

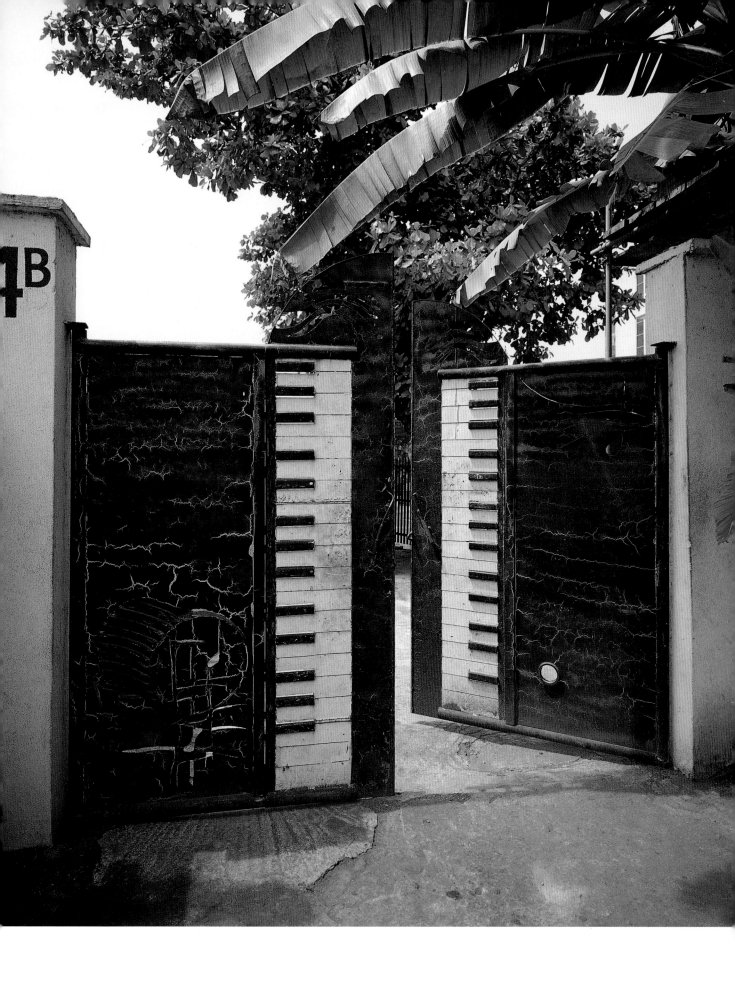

Olu Amoda

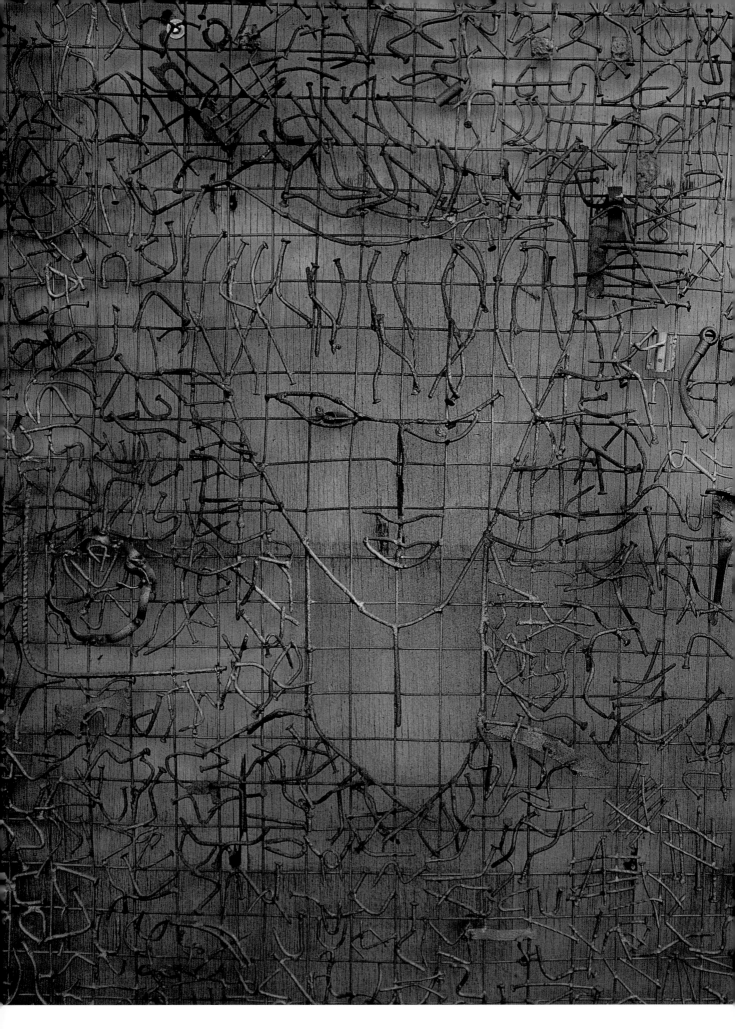

Out of the Ordinary: Spectacular Craft

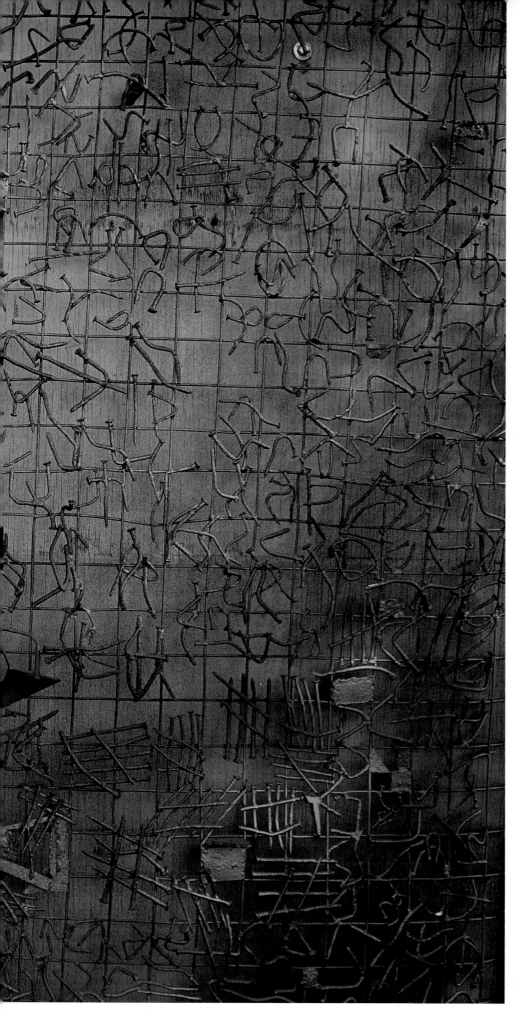

**Olu Amoda**
*Queen of the Night*, 2003
Chicken wire mesh, nails and
scrap metal on board

**Olu Amoda**

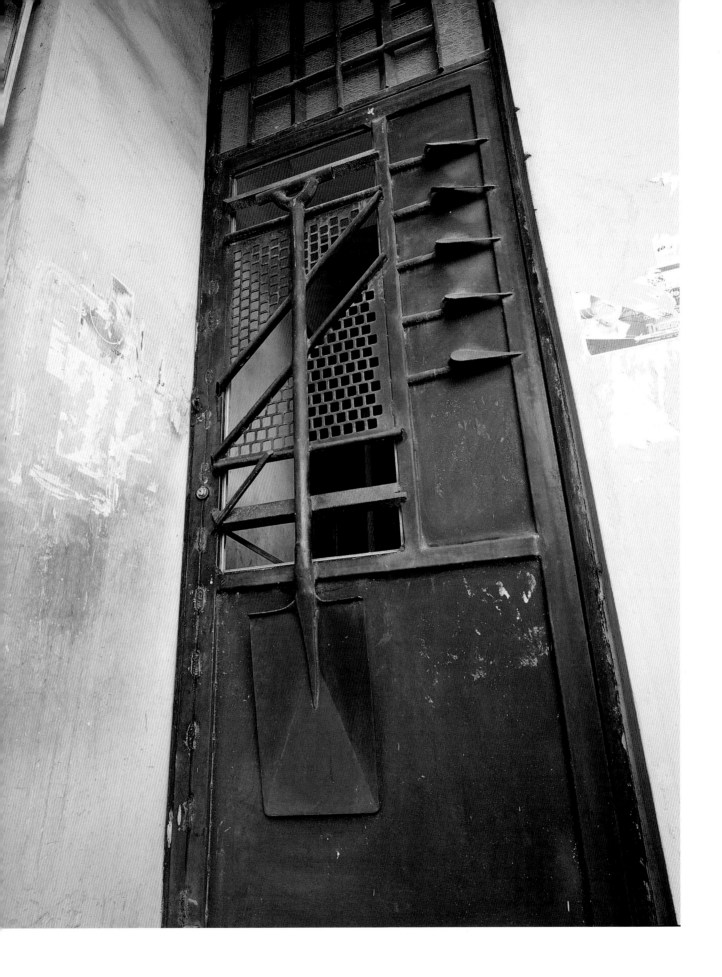

Out of the Ordinary: Spectacular Craft

**Olu Amoda in conversation with Laurie Britton Newell**
North Carolina, November 2006

Olu Amoda
*Concrete Lab Door to Yaba*
*College of Technology*, 1995
Steel, glass

LBN **Why are you preoccupied with ordinary things?**

OA What we call little things are merely the causes of great things: they are the beginning, the embryo, and the point of departure, which, generally speaking, decides the whole future of an existence. One single black speck may be the beginning of gangrene, of a storm, of a revolution.

LBN **How do you manage being a sculptor and a designer at the same time?**

OA Some of the early reactions to my sculptural work from collectors [were] 'it's too heavy, too big,' and design and architecture sort of came to my rescue, giving me forms and scales I could work with, a place to fit. So I have dabbled in design and architecture, and come back to sculpture, and somewhere in between realized that the language and the materials I am using can cross over. It's important to me that I am the same person. My concerns are the same, whether I am doing a commission for a client's doors or a freestanding sculptural piece. There is a saying that if you climb the same mountain many times, you will learn more than climbing many different mountains.

LBN **Can you tell me a little about your working process?**

OA I use several different types of welding techniques—arc, MIG and TIG —to bring together found objects. I play with the different surfaces these techniques give you. [arc welding, a method of joining similar materials by heating using an electric arc and a filler metal; MIG (metal inert gas) welding involves a continuous wire feed; TIG (tungsten inert gas) welding uses gas to protect the molten metal from the atmosphere to produce a high-quality, precise weld]

LBN **Do you ever use a combination of different welding on a piece?**

OA Technically you are not supposed to, but like any good artist I break the rules. If I have used TIG in a piece but am not sure the join is strong enough I do it again with MIG. My aim is not to do things like a professional welder but to bring together materials that tell the story I want to tell.

Several pieces I have been working on at the moment include non-ferrous materials such as keys, as some are made up from steel and others alloys containing a lot of zinc. This makes them very difficult to weld. So I have had to find ways

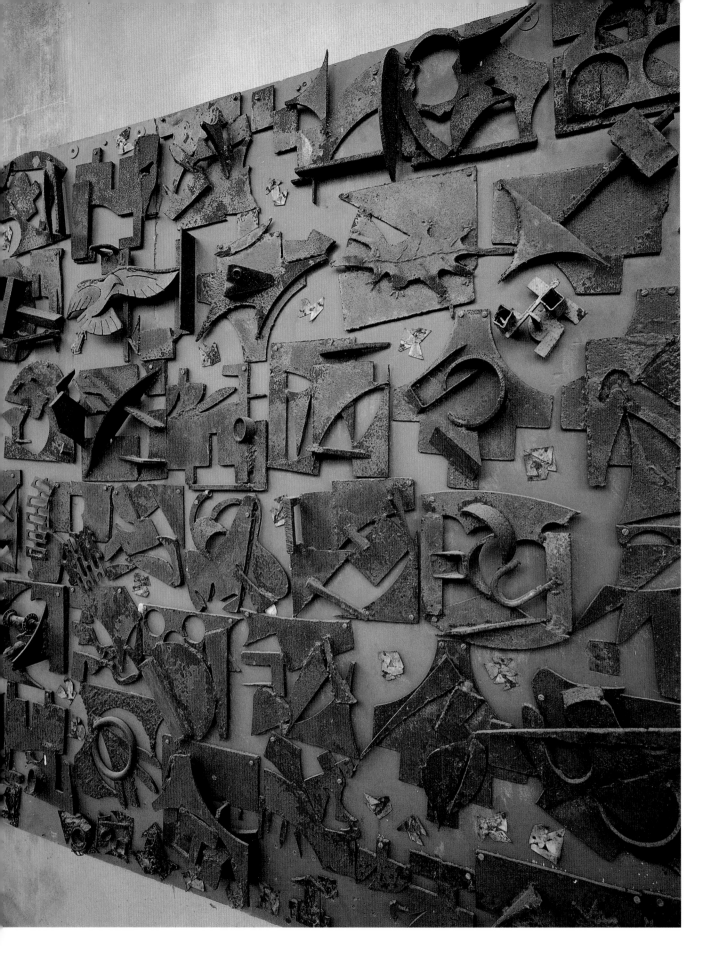

Out of the Ordinary: Spectacular Craft

around this, introducing other metals, and welding that to the armature to hold the keys in place. I try out different joining techniques. I am not re-inventing the wheel! But two objects' incompatibility is not an excuse for me not to use them. I like to be challenged by materials and find solutions to working them. Back in my studio in Nigeria sometimes you go for two weeks without electricity, and again for me it's about seeing the situation and rising above it. So a crisis like no power causes me to put works together in new ways. A difficult situation stops being a challenge and becomes an opportunity. That is not to say I like going around looking for difficult situations, but it's definitely a place you find yourself more often than not.

LBN **You have used nails a lot in your work. Can you tell me about their particular significance to you?**

OA Nails are used in my works as a metaphor. I find their shape and material very compelling. Nails have survived generations and remain one of the most ideal pieces of engineering to have come of age. There are very few similar objects or tools that have multiple functions yet at the same time retain a strong

identity. To think that back in the time of the Roman Empire the early nail was handmade, and interestingly today nails are one of the few remaining components that craftsmen still prefer to handle while working. Most carpenters not only handle but sometimes store nails in their mouth while working, as if they require human contact for efficiency in some way. Some entertainers see nails as the defining moment of endurance, some sleep on a bed of nails, some drive nails through their nasal cavity. The qualities of nails are endless and subject to many interpretations. Nails depend on the notion of shared responsibilities, very much like the ants. Small but lethal, a nail is able to defend itself, but yields to the will of the craftsman. All these characteristics can be a useful decoy when addressing social issues. For me it is the sheer availability of the nail and its propensity to live several lives that make it simultaneously an interesting tool, object and medium.

Olu Amoda
*This is Lagos (Grey)*, 2002
Welded steel on board

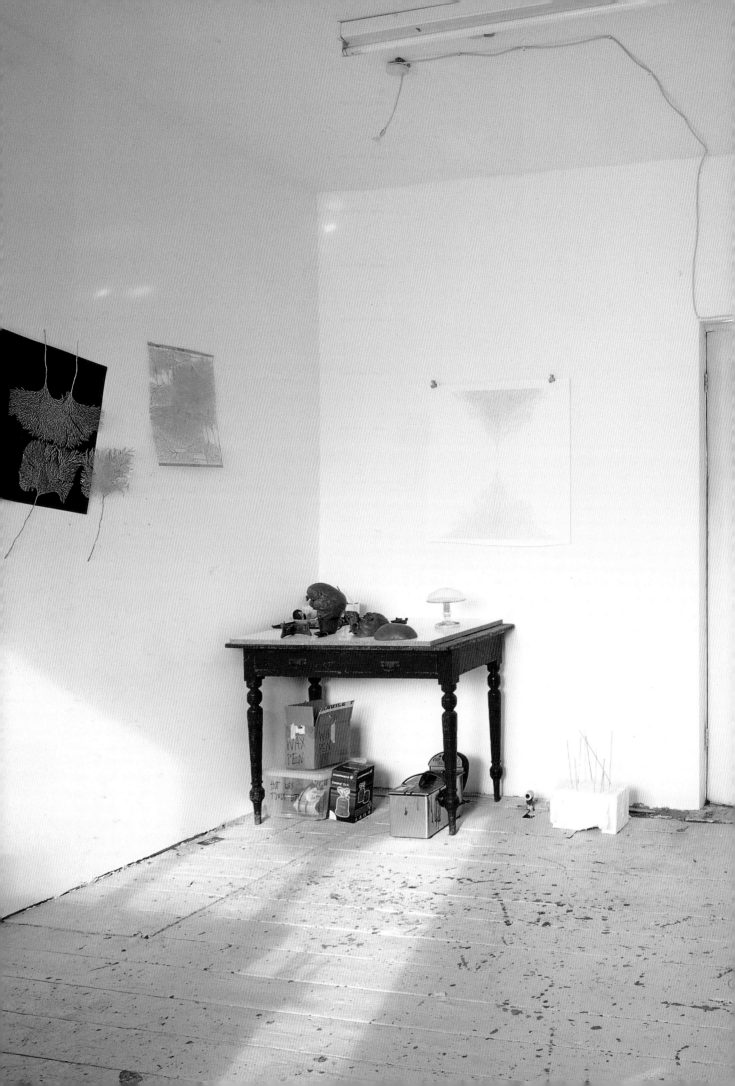

# Annie Cattrell

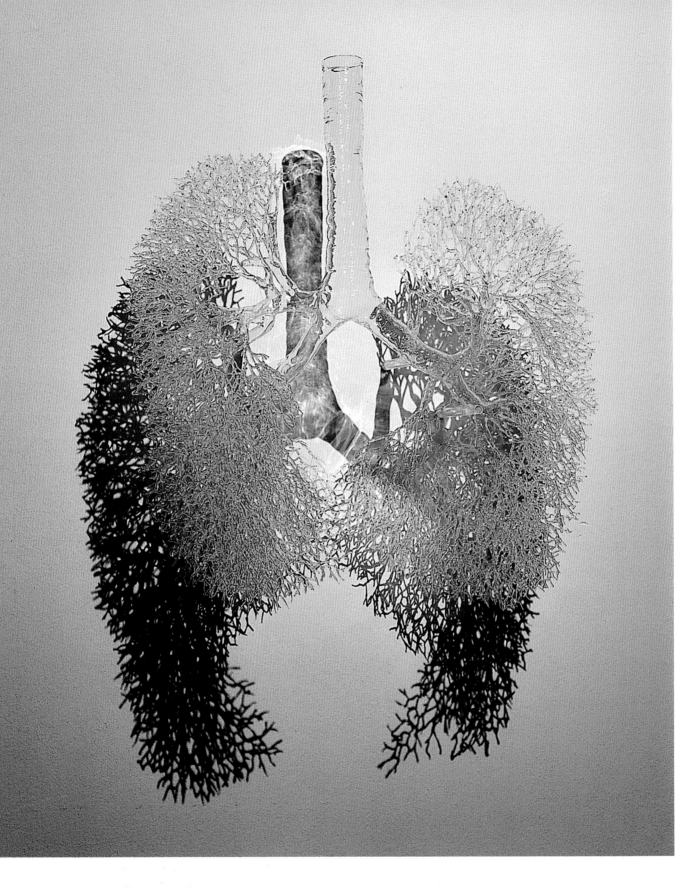

**Annie Cattrell**
*Capacity*, 2000
Lampworked glass

**Transparent**
Laurie Britton Newell

Annie Cattrell's work can be read as series of captured moments in time: sunlight on a particular day, a human breath, a split second of brain activity or a passing cloud. Her subjects are often the result of substantial research into scientific areas of study, such as anatomy, neuroscience and meteorology. But she does not approach these areas as a scientist—quite the opposite. She is interested in being an outsider in these complex fields, exploring and mapping territories that are new to her. She does not solely aim for scientific accuracy (although this is important to her): instead Cattrell provides a different way of looking at the things that are inside us and around us.

Several of Cattrell's works address a view of what is inside the body. *Sense* attempts to map the way the brain registers the senses in three-dimensional form. With functional magnetic resonance imaging (FMRI) the areas of the brain that respond to seeing, smelling, hearing, touching and tasting can be seen to 'light up' when experiencing stimulus. Using rapid prototyping Cattrell modelled their forms and suspended them in acrylic blocks to show the actual locations and volumes of the individual senses within the living human brain.

Cattrell frequently works with resin and glass, drawn to the transparency of these substances and their ability to reveal. Sometimes she employs complex processes such as lampworking, as in *Capacity*, a three times life-size pair of human lungs which exposes the interface between the interior and exterior of the body. Lampwork is a technique that involves heating a small area of borasilicate glass, making it molten enough to manipulate whilst the rest of the piece remains cold. It is an intricate process originally invented for the production of laboratory equipment, test tubes and the like, and now more commonly associated with trinkets and menageries of small glass animals.

Previous spread
Annie Cattrell's studio in South
London, UK, 2006

Cattrell has also been preoccupied with ever-changing cloud formations and their similarity to the physiological changes within the human brain and body, and has researched the way particular pieces of scientific apparatus can measure and act as conduits to help realize such intangible things. When Cattrell started researching weather patterns she met the meteorologist Stan Cornford who, in the 1960s, had invented a measuring instrument, made partly of malleable metal foil, which documents the density and size of water droplets within a cloud. When the instrument is extended from an aeroplane the suspended water droplets of the cloud leave imprints in the foil, mapping its shape. A similar transformation of the ephemeral into the permanent occurs in Cattrell's *Conditions* series, in which small floating clouds appear to be trapped inside blocks of glass. This effect is achieved using laser scanning techniques to etch three-dimensional forms point by point inside solid glass. These works capture forms that are the very definition of ephemerality and inaccessibility, and bring them down to earth.

Campbell-Stokes Sunshine Recorder

Cloud foils by meterologist Stan Cornford

Another such piece of equipment is the Campbell Stokes Sunshine Recorder, which has been in use since the late nineteenth century. It records the hours of sunlight on a particular day by focusing the sun's rays through a solid glass sphere, burning patterns on a piece of card as the sun moves across the sky. In 2003 Cattrell created *Aperture*, in which each of sixty-two suspended A4-sized stainless steel panels bears a record of the unique formations of sun rays on particular days up to 21 June 2003.

Drawing is an important aspect of Cattrell's practice. She is intrigued by the underlying patterns and genealogies that link everything in the natural world, discovering how disparate things are connected and how they can be interpreted visually. In large pencil drawings such as *Sustain* growth patterns and networks of lines are interwoven and layered. In *Brink* she uses the paper as a material to work into rather than draw on. Thousands of small incisions, each one a directional vector shape, move through the page and stop abruptly. These works are equally reminiscent of a topological map of a mountain range or a polar bear pelt.

Cattrell's work challenges our recognition of the human body in the physical world. In the far-reaching scope of her work she relates diverse fields—meteorology, anatomy, neurology, and so on—in an exhaustive quest to make art include, and make visible, that which is normally unseen.

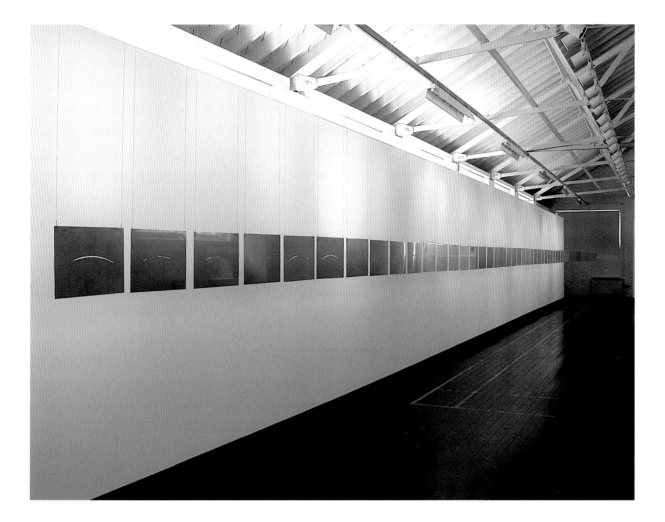

**Annie Cattrell**
*Aperture,* 2003
Laser-cut stainless steel

**Annie Cattrell**

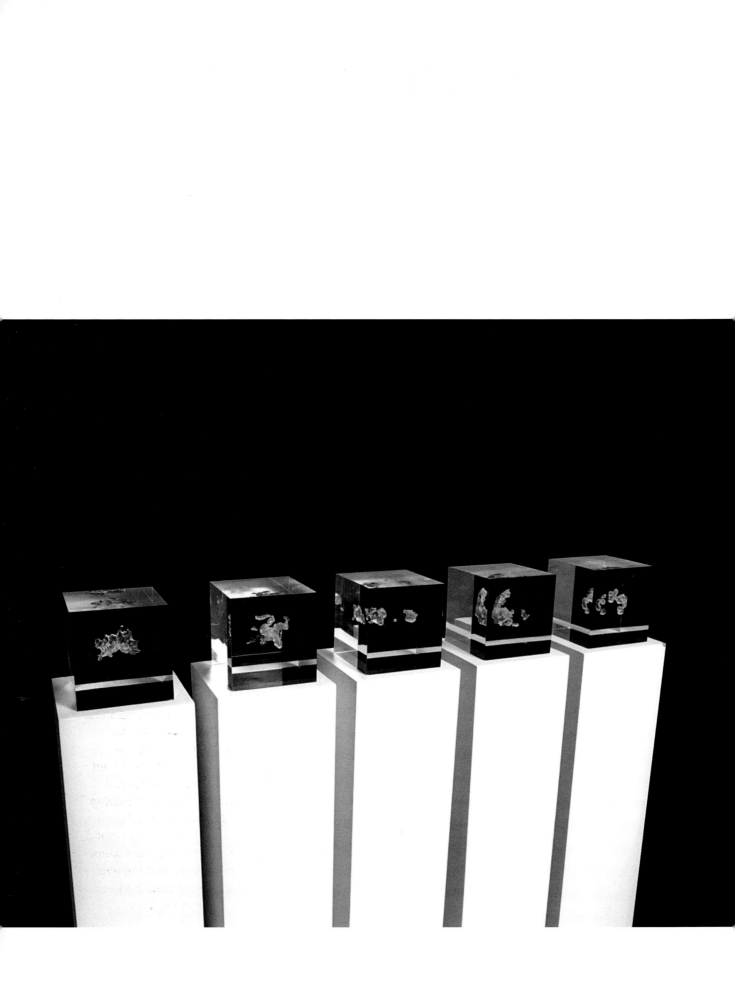

**Out of the Ordinary: Spectacular Craft**

**Annie Cattrell in conversation with Laurie Britton Newell**
London, October 2006

LBN **Can you pinpoint the beginning of your preoccupation with capturing, and making solid, the evasive and ephemeral?**

AC My father was a radiologist and he showed me x-rays from an early age. He described the world in pragmatic terms, i.e. the certainties of life such as birth and death, the infinite ripples on the surface of water when disturbed… which to me was [more] grounding and wondrous than the other explanations of how and why we exist.

It also stemmed from an artist's residency I undertook in a psychiatric hospital (Royal Edinburgh Hospital) in 1990. This led to thinking about the relationship between the brain and the body and how both are physiological entities. The brain is as active as any other part of the body, in fact more active, neurons firing at high speed night and day.

LBN **So the relationship between the brain, the lungs, the clouds in your work is making something visible that is usually unseen?**

AC I have chosen to isolate particular natural and living entities such as the interior chambers of the heart, the lungs and cloud formations in some respects because they are in constant movement and flux. In

*Conditions* the clouds are reduced in scale and the way they are exhibited allows the viewer to look down from above into them, an outsider's or godly perspective. Seeing the familiar in a new light.

In relationship to work using the human body (i.e. the interior cast of the mouth, nasal passages and the inner ear) I am interested in making visible the spaces and places where inside becomes outside, where the senses are felt but not necessarily seen. *Capacity* isolates the lungs (the organ of air) and makes visible the fragility of the atmosphere we live in and how the substance of oxygen becomes part of us.

LBN **Are you picking out things that are common, familiar, to form a relationship with your audience?**

AC I choose the familiar, for example, a cloud so whatever language you speak, there is kind of a universal understanding. It is the transformation and freezing into three dimensions of this iconographic subject matter that interests me: what happens when you contemplate something you think you know but shouldn't really be seeing in this way.

**Annie Cattrell**
*Sense,* 2003
SLA rapid prototype in resin

LBN **Does that also tie in with research collaborations with scientists? Are you trying to create something accurate?**

AC  Yes, in part. When working with specialists in any field—meteorologist, scientist, neuroscientist, anatomy specialist— they have a responsibility to be accurate. A scientist wouldn't necessarily call themselves a scientist unless they were in a job, an institutional structure: a methodology. Artists on the contrary often work without institutions, although with no less rigour. It is the connection between the creative approaches and methodologies of both art and science that informs my work.

LBN  **You have worked with all kinds of materials and new technologies. Processes really intrigue you. Why are you particularly drawn to transparent materials?**

AC  I don't particularly like people to touch my work, partly because it is fragile, but also because it is about how you look at it. If I wanted to make a sculpture to be touched it would probably be very different, in fact about the process of touching. The artworks made out of transparent materials are for me

about illuminating ideas, making things visible, somewhere between idea/theory and reality.

At school I enjoyed organic chemistry very much, being in the lab, experiments, Petri dishes, test tubes, looking down the lenses of microscopes, allowing you to see something normally not considered interesting or visible… a window into another world and way of thinking.

LBN  **Going back to the clouds, is there something about the scale which brings out the illusion of control?**

AC  How interesting to be able to control the uncontrollable, i.e. to stop momentarily and arrest this everyday cycle. Clouds are in an incredible state of suspension as they are held up in part by hot air and wind. Scaling these extraordinary natural phenomena down and encapsulating them into a block of solid transparent material may allow the viewer to contemplate the subtle transient nature of the world and our responsibility to the place we inhabit.

**Annie Cattrell**
*Brink* and *Forces* (details), 2006
Cut paper

**Annie Cattrell**
*Sustain,* 2006
HB pencil on paper

**The text below is included as a pendant to Cattrell's series *Conditions*, which depicts meteorological effects with extraordinary verisimilitude.**

## Common cloud classifications

Clouds are classified in a system that uses Latin to describe their appearance as seen by an observer on the ground. The table below summarizes the four principal components of this system (after Donald Ahrens, *Meteorology Today: An Introduction to Weather, Climate and the Environment*, fifth edition, West Publishing Co., 1994).

| Latin | Translation | Example |
| --- | --- | --- |
| cumulus | heap | fair-weather cumulus |
| stratus | layer | altostratus |
| cirrus | curl of hair | cirrus |
| nimbus | rain | cumulonimbus |

Further systems of classification identify clouds by the height of the cloud base. For example, cloud names with the prefix 'alto-', as in altostratus, are found at middle levels. The first three groups given below are identified based upon their height above the ground. The fourth group consists of vertically developed clouds, while the final group is a collection of miscellaneous cloud types.

## High-level clouds

High-level clouds form above 20,000 feet (6,000 metres) and, since the temperatures are so cold at such high elevations, are primarily composed of ice crystals originating from the freezing of supercooled water droplets. High-level clouds are typically thin and white in appearance, but can appear in a magnificent array of colours when the sun is low on the horizon. The most common high-level clouds are cirrus, which generally occur in fair weather.

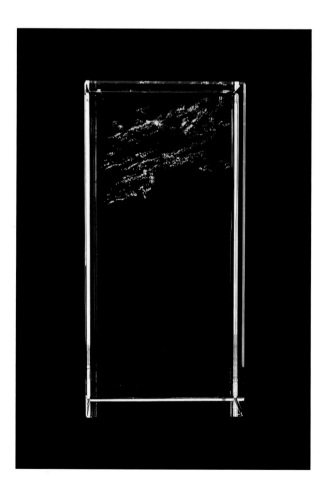

**Annie Cattrell**
*Conditions*, 2006
Subsurface etched glass

## Mid-level clouds

The bases of mid-level clouds typically appear between 6,500 to 20,000 feet (2,000 to 6,000 metres). Because of their lower altitudes, they are composed primarily of water droplets; however, they can also be composed of ice crystals when temperatures are cold enough. Typical mid-level clouds are altocumulus, which usually form by convection. On a warm summer's day their appearance is usually followed by thunderstorms.

## Low-level clouds

Low clouds are mostly composed of water droplets since their bases generally lie below 6,500 feet (2,000 metres). However, when temperatures are cold enough, these clouds may also contain ice particles and snow. Nimbostratus are dark, low-level clouds accompanied by rain or snow.

## Vertically developed clouds

Generated most commonly through either thermal convection or frontal lifting, these clouds can grow to heights in excess of 39,000 feet (12,000 metres). The most familiar is the cumulus cloud, which in fair weather exhibits only slight vertical growth. In favourable conditions, however, they can develop into the towering cumulonimbus clouds associated with thunderstorms.

## Other cloud types

These include orographic clouds—formed by the forced lifting of the air over rising land; pileus clouds, smooth caps that form over mountain tops or cumulus towers; and mammatus clouds, rare examples of clouds sinking in air.

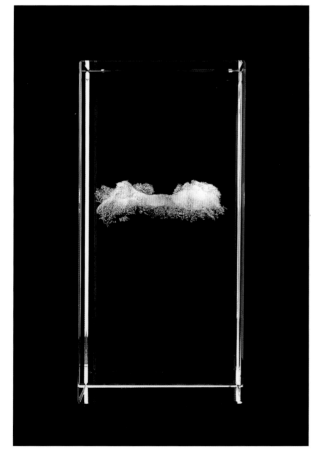
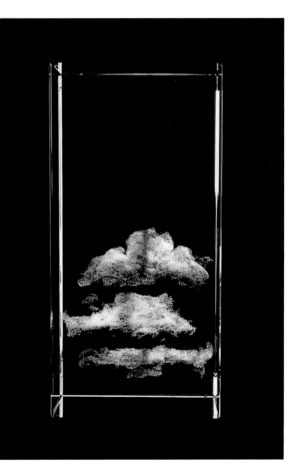

**Annie Cattrell**

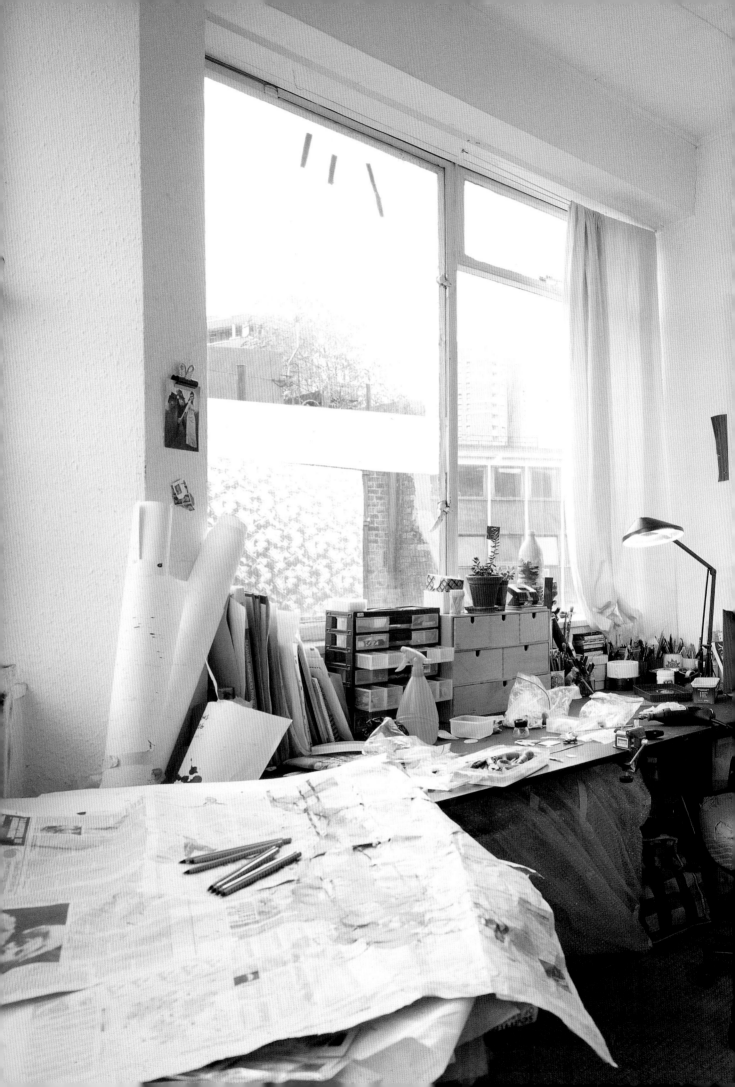

# SUSAN
# COLLIS

Out of the Ordinary: Spectacular Craft

**Susan Collis in conversation with Laurie Britton Newell**
London, December 2006

LBN **You had a previous career in publishing. What is your background and what made you take up art?**

SC My first degree was in cultural studies and I specialized in literature, mainly American. To be honest, and it's a pretty embarrassing thing to say, but I made the switch because I married an artist. I'd be really interested to meet other artists like me, because sometimes I feel like a charlatan. I guess I've therefore had to challenge that idea of an artist being someone who is born to create their art. I wanted to be a songwriter or a poet when I was younger. After I left college I did try to write a novel for years; I had this idea, which I still think would make a fantastic book, but I just couldn't get it together and when I had the opportunity to start making art I found an outlet for that creativity that worked. It was unexpected because I hadn't thought that was me at all. When I went to art college, I remember being told off for saying that a piece was poetic, but I do feel that there is some kind of poetic sensibility in my work. I think it's just about getting materials and process to make a kind of poetic language. I think that often successful poetry is the butting together of things; two words that are brought alongside each other and the combination creates a third meaning. I've always wanted my work to do that … to put together two different opposing terms, like tidy and untidy, clean and dirty—to bring them together and see what happens. I think that this ties into my feelings about craft. Craft in my mind, and maybe in quite a lot of other people's minds, has that 'good' label.

LBN **Worthy …?**

SC Yes, and that's what really sort of draws me to craft. To make something look bad, dirty, stained using these processes that are usually deemed to be good and worthy, to jumble the two up.

LBN **Why are you so drawn to stains and blemishes?**

SC I'm very preoccupied with the actual production process of art. I started with these splash and stain motifs because they are the residue of art making. At college these marks were all that was left of all of the art production that had taken place in that environment. I wanted to find a way that I could make work that hid itself, and these marks that are usually ignored seemed like an ideal place to start. Increasingly the

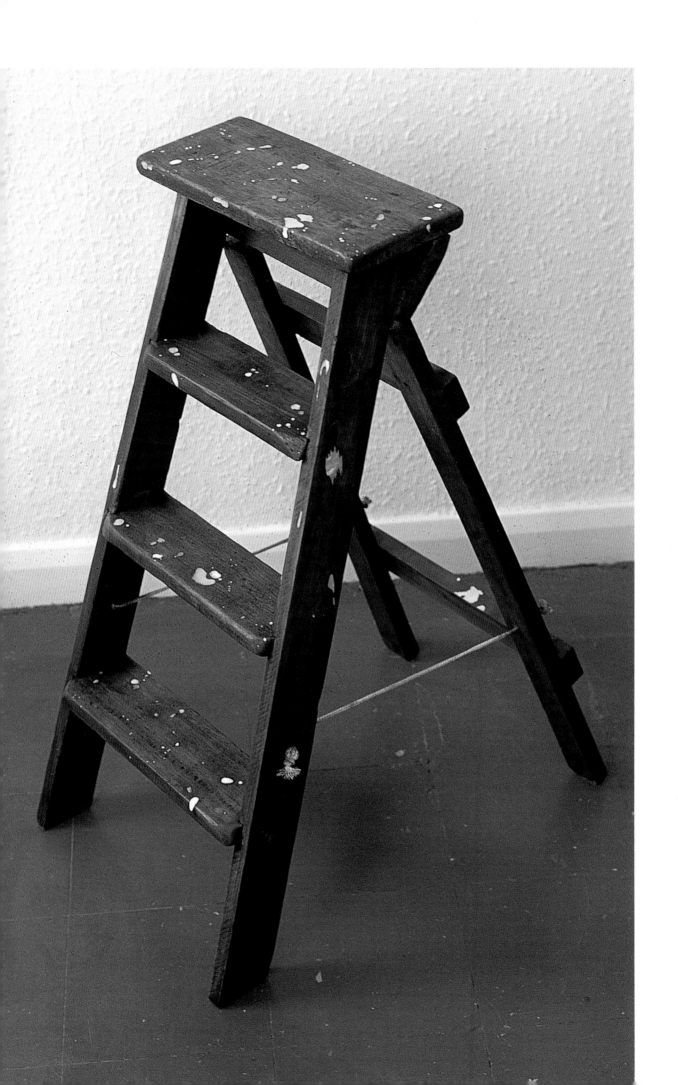

production side of things is hidden. Production is art's dirty secret. Also, I think I'm always trying to pick apart this idea of creative genius, the big 'why' of creativity. Effortlessness is what I equate with genius, making a few loose marks on a canvas and being able to create perfection. I have a love/hate relationship with this notion— there's a side of me that wistfully hankers after it and another side that questions it.

Then I became interested in how art is shown and where, and the idea that nothing really messes with that. I know that there are a lot of cases where art is taken out of the gallery but to a large extent it's still being seen in fairly pristine surroundings.

**LBN** **And you like to intervene and mess about with that? Have you ever shown your work in a non-gallery/museum context?**

**SC** I have shown in a school and a church. But I don't know how I feel about it because I think that took the work in another direction. I didn't feel that they were my ideal environments. I suppose I am more comfortable with the nest I've made myself in gallery spaces. I like doing something that subverts a clean environment, so starting with a more or less blank canvas of a space is important to me.

**LBN** **What is the ideal way you like people to encounter or interact with your work?**

**SC** My ideal viewer is somebody who is quite dismissive of the work to begin with and then has that moment of recognition. I've always got the audience in mind, in a really big way. What got me excited about carrying on making the work was the reaction I got with the first piece that I made, the stitched overalls. The honest truth is that I had no idea that they would do the *trompe l'œil* thing. I set out to make them as realistic as possible but I still thought you would see the stitches when you looked at them. It was a real surprise to see the reaction I got and I really loved watching the moment when the penny dropped.

When I was still at college someone suggested that I looked at an artist called Charles Ray. He is a great influence for me. The way he plays with reality. He made this lovely piece of work that is a drawing in space. There is this continuous line that comes down from the ceiling to the floor. It's actually a fluid line of printer's ink that disappears through a hole in the floor and runs through hidden pipework. If you put your finger in it would go everywhere. I love the tension that this piece holds in it—the dual ideas of unbelievable perfection and mess.

**LBN** **Can you tell me a bit about the concepts of value and accuracy in your work and your practice?**

**SC** One of the things that I really enjoyed about working on the overalls was studying how marks appear on the surface in different places, what happens when paint goes over a seam, for example, and copying that with stitches.

To begin with I did lots and lots of unpicking when I realized that [the stitches] had to be really quite small to appear authentic. And then they become precious somehow, and there was something—I know that it sounds naff—of value in those little tiny stitches, in that attention to detail. The devil really is in the detail.

**Susan Collis**
*The oyster's our world*, 2004
Wooden stepladder, mother of pearl, shell, coral, fresh water pearl, cultured pearls, white opal, diamond

There is something poignant that I admire about trying really hard in the face of adversity, quite an English thing I suppose.

I like the idea of not taking things for granted and I like the idea of learning how everything's made and the humility of making it yourself. There's no better way to learn how something is made than to do it yourself.

LBN **I remember you saying that the stepladder took about six months to make, is that true?**

SC    Yes, the first stepladder probably did take about six months. And when I first started getting commissions for them I was horrified. Now I've learned the inlaying techniques a bit better, I can make a commission in about two months. It's pretty intense work, long hours, but there is a real pleasure in doing something that you've done before and knowing you know what you're doing.

LBN **Presumably these are quite repetitive manual processes?**

SC    Yes, some are more repetitive than others. Though the process is similar each time, it is only really as repetitive as painting. I manage to maintain an interest because I am making a new version each time, with different variations and processes. I try to work on a combination of pieces simultaneously, drawing, cutting or sewing. Also I don't think of it as repetitive because I find interest in the tiniest variations of constellations of marks. I get quite excited about a kind of splash I've never seen before. I'm always looking at people's overalls and tables and floors. Although, actually, splashes are pretty uniform. I'm constantly coming across the same kinds of patterns or marks. The shapes depend on velocity and the viscosity, how thin liquid is, the surface, etc. I am an expert on splashes!

Susan Collis's studio in
East London, UK, 2006

Out of the Ordinary: Spectacular Craft

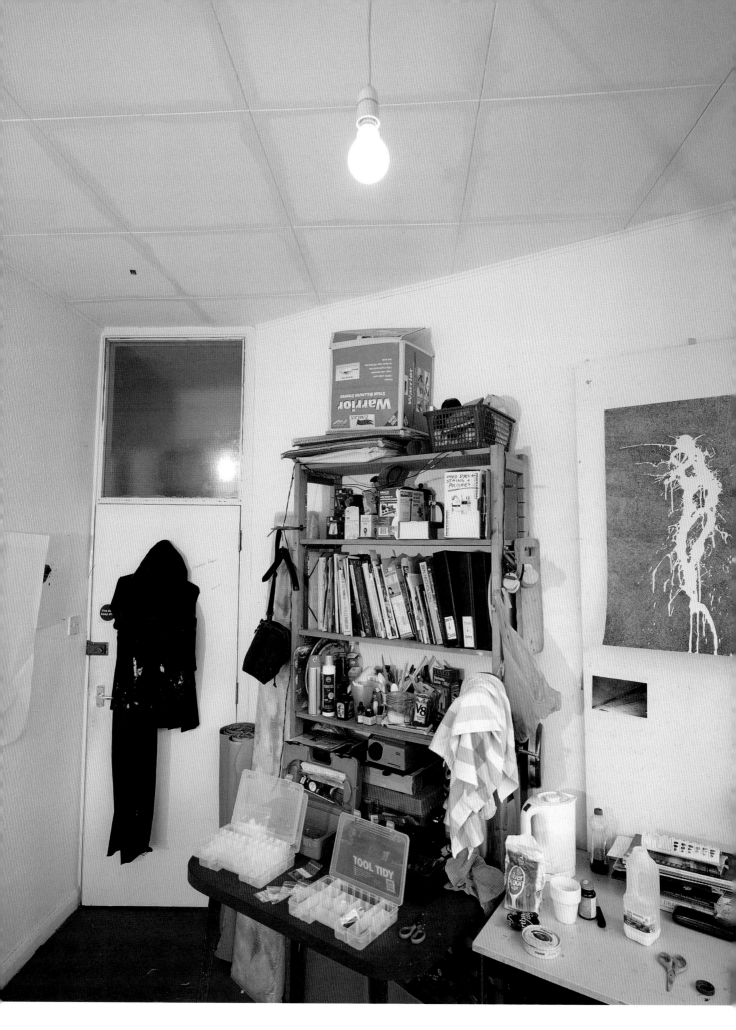

**Susan Collis**

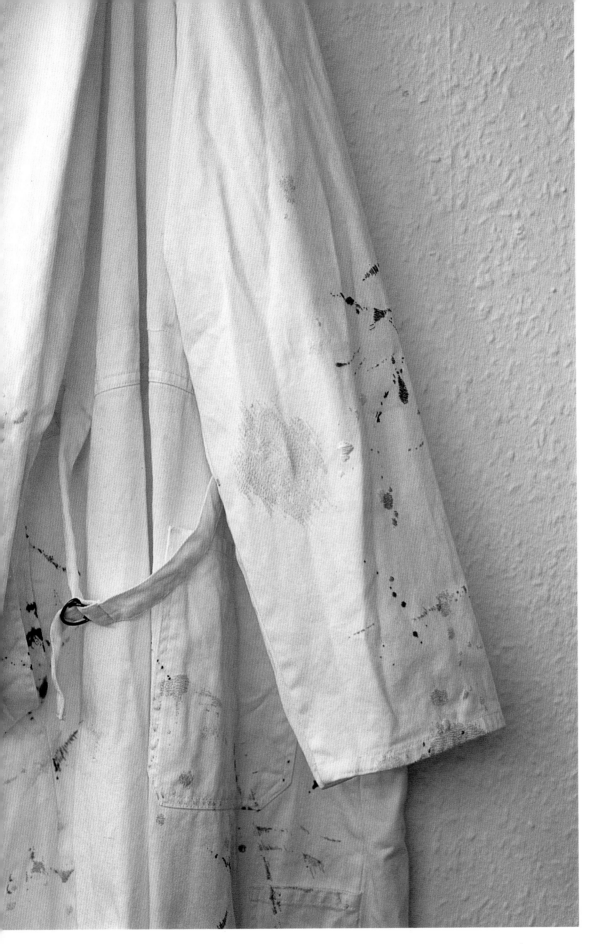

**Susan Collis**
*Paint Job,* 2004
Boiler suit, embroidery thread

**Out of the Ordinary: Spectacular Craft**

**Susan Collis**
*Something Between Us*, 2003
Pencil-drawn crack
Installation at Beaconsfield Gallery, London

**Susan Collis**

**Susan Collis**
*Work on It* (detail), 2002
New table, wood-effect
adhesive wings

**Out of the Ordinary: Spectacular Craft**

**Making as a Means, Making as an End**
Jonathan Hoskins

The V&A is not a contemporary art gallery. Objects on display are made distinct from the surroundings by conventions as old as the objects themselves. Images go in a frame, sculptures rest on a plinth and so much else is cradled in a mount. A straightforward transposition of the 'suspension of disbelief' asked of a theatre audience; the aesthetic eye can be cast so far and no further. Susan Collis's work is not like that. The further you look, the more you might find.

In museums there are 'objects' and 'everything else'. Each object is treated with a kind of reverence that any other context could only make surreal, and exerts an influence on everything around it. Its nature determines everything from the materials in the vicinity to the atmospheric conditions it is exposed to. Technology is brought to heel; electric screwdrivers may be indispensable elsewhere but create vibrations damaging to a great many museum objects and so cannot be used where such energy could be transferred.

Everything is swept away before the exhibition opens and the only trace of curators, conservators and technicians having been there at all is the completed exhibition itself. Obviously, this doesn't apply here with Susan's work; the two are all but collapsed in on one another.

I don't think Susan is quite right; 'production' isn't art's dirty secret. Production can work in the artist's favour. I've never known an artist be ashamed to tell of how a piece of work was produced by someone (or something) else. I think the Cartesian separation between mind and body remains very deeply culturally embedded in all of us, and so when an artist tells us they had nothing to do with the fabrication of a piece of work, that their body was redundant in the process, it only underlines their role as the originator of ideas, the *artist*, and not the 'technician'. No, 'labour' is art's dirty secret, personal labour, graft. After all, labour is toil and how can something that toils be anything approaching genius?

So I find it funny that the production of Susan's work could almost have been executed by someone else. No elevated status for her! What could have been a condescending look at people who get their hands dirty for a living is instead more like a joke at the expense of the idea of genius.

This all says a lot about museums, what they're for and why they're there. I hope this seems more than academic. Add to it all the conspicuous absence of people, the ones who left the now-sanctified marks, stains and damage, and the work becomes like a premature social history. It speaks of worth, value, labour, posterity, longevity and action.

# Naomi Filmer

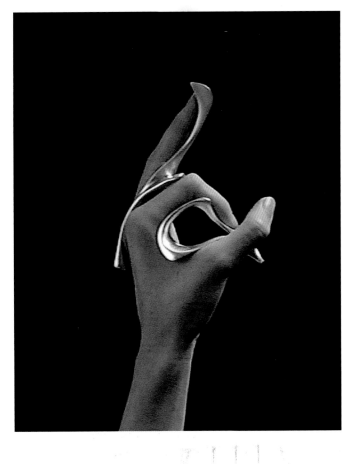

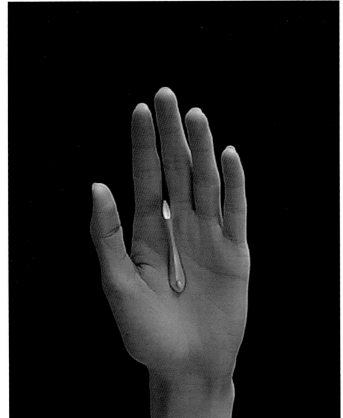

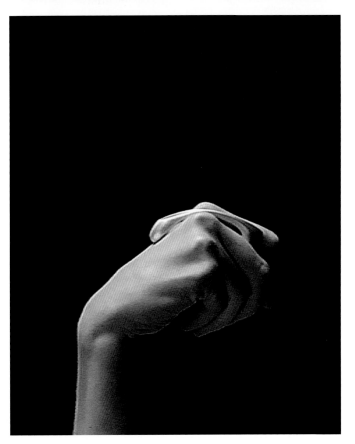

Previous spread
Naomi Filmer's apartment and
studio in Milan, Italy, 2006

**Out of the Ordinary: Spectacular Craft**

**Naomi Filmer in conversation with Laurie Britton Newell**
Milan, December 2006

**Naomi Filmer**
*Lenticular Series 1*, featuring
*Hand Manipulation*, 2006
Animated integral image,
produced by Create 3D
and BluLoop

LBN    **What are you working on at the moment?**

NF    Firstly I am wrestling with how to exhibit jewellery as a non-static object. If you can't have a live model strutting around, which I don't want, it's too fashion and unpractical, then usually you have a static image to illustrate the object in context. But at the moment I am experimenting with moving images. For me the way to view my objects best is when they are in motion, so I am exploring ways of illustrating the object as a moving image, be it animation, a film loop or my most recent discovery, 'lenticulars' (high-tech holograms). [The process involves extracting animated 3D images from video footage and processing them through patented software to create a print that gives an illusion of depth or movement as the viewing angle changes: see www.create-3d.co.uk.] But a large part of this attention on how to exhibit my work is about my intention to illustrate the experience and sensation of wearing the work. So I find myself more involved in the experience of wearing or viewing rather than the method of making… and in fact moving further away from the final object. What something feels like is at least as important as the piece itself.

LBN    **Do you think about your work as a type of performance or spectacle?**

NF    At no point have I thought about my work as performance. I guess the closest I have got to performance is collaborating on catwalk projects, which is a theatrical setting in many ways. And I don't think of film as performance, I think of it as animation. I am interested in theatre, so it's an interesting point, but I am not comfortable with my work under the title of performance, because it suggests that you are a spectator to the work. But I want my work to be a physical experience, not a passive one. That goes for my early work too. The pieces were never made for an audience, but for the wearer. Spectacle is perhaps the wrong word, maybe spectacular; how spectacular the body is in itself. Physical experience is spectacular. If I highlight particular body areas it will always have a reference to sensation; behind the ear, between toes, areas that are very sensitive, personal, private spaces.

LBN    **Could you say in fact they are the forgotten parts of the body, the un-spectacular?**

NF    Precisely.

LBN **How do you respond to the title *Out of the Ordinary* in relation to your work?**

NF I am comfortable with the term because I am not interested in ordinary jewellery. If you showed images of my work to Joe Bloggs on the street they probably wouldn't think it had anything to do with jewellery, but would see that it had something to do with the body. When you consider the sensibilities of jewellery it fits with what I am doing… attention to detail and physical fit.

The work I have made focuses on ordinary parts of the body that we never really celebrate, but actually there is nothing ordinary about them at all, they are unique to every individual. Also the whole idea about finding inspiration in the mundane. I like it.

LBN **Where did your interest in the ephemeral originate?**

NF The ice pieces partly came from work I had made in cast glass. I was drawn to glass because I was tired of the solidity of metal. I wanted something more transparent and turned to glass but soon discovered that it was a really difficult and unpractical material for what I was trying to achieve. Ice was an obvious connection because of the translucency; cast glass looks like ice. But additionally I was into the idea of ice on flesh and how it starts to melt immediately. I love that point of contact, the idea that the body temperature breaks down the state of the ice. The wearer wears out their own jewellery. It's a play on words, but I've always been interested in the concept that contemporary jewellery wears *you* rather than you wearing the jewellery. But in both the *Ice* and *Chocolate* series the wearer

physically dominates the objects by breaking down their very state, rather than posing as a mere backdrop. Another reason I arrived at this was after having worked on a few catwalk shows I realized something really bothered me, and in the end I recognized that for me the problem was that the body was treated as a clothes hanger. Looking back I think the pieces I made for the catwalk often drew attention back to details of the body, reminding us that this was a physical form, a human body.

I think as soon as you are made to think of a particular part of the body, behind the ear or between the toes, you are made to think in a much more physical way. If you direct people's attention to this you appeal to a shared experience, or evoke a familiar, more visceral response. It jerks them into thinking about themselves, their own body.

LBN **Is that why you are so drawn to dance and movement?**

NF Yeah, some sports too, to see what shapes a body makes and the capacity of the human form through movement.

LBN **At the moment you seem to be working in a number of different ways and places simultaneously. How do you manage to juggle designing commercial jewellery in Milan, your own conceptual projects and teaching in both London and Milan?**

NF It's very rare that I have all three going on at exactly the same time, and when they are all full on at the same time, I don't handle it very well. But I do enjoy the balance that different work demands. I sort of have to saturate myself into each project. Ideally I like to work for intense pockets of time, one time,

**Naomi Filmer**
*Ice Jewellery,* 1999
Ice

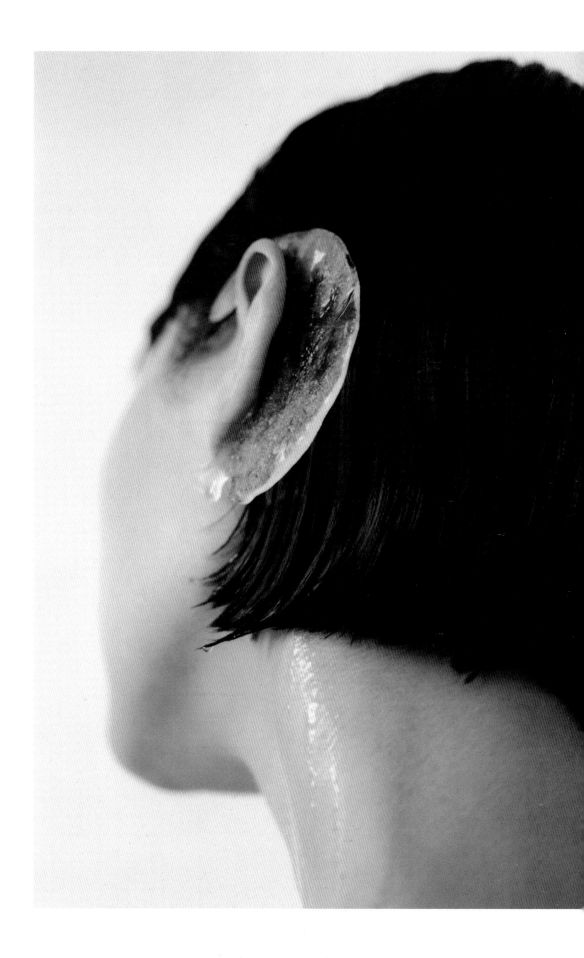

**Naomi Filmer**

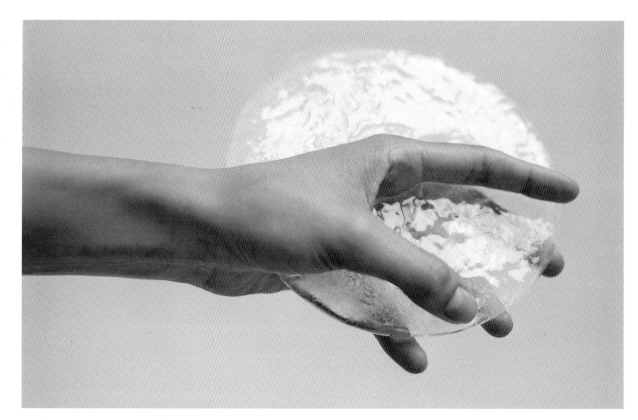

**Naomi Filmer**
*Ice Jewellery*, 1999
Ice

**Naomi Filmer**
*Chocolate Gloves*, 2000
Chocolate

one thing, one place. Each project requires quite a different headspace. Working on commercial jewellery, for example, feels like role-playing, like designing jewellery for a movie, a play. Whereas teaching requires you to work your way around many people's individual ideas in a very short space of time and make sense of it, first to yourself and then feed back to the student. It is completely opposite from working on your own, when you are in your own headspace for long periods of time, with your own dialogue going on. I think teaching is often a relief and a good exercise for assessing ideas and directions. It keeps me on my toes. But in the end I am passionate about all the projects… I am surprised how passionate I am about the commercial work. But I am reluctant to talk about those projects as they're so opposite to my own projects and source of inspiration, but it is still important to me that they get a good result. Commercial doesn't have to be ugly, after all.

LBN  **With a lot of your projects you collaborate with other people, working a bit like a producer. Are you completely removed from the hands-on making? How does that fit with your training?**

NF  Yeah, working with various materials means that I seek out craftsmen who specialize in those materials. It's inspiring to work with and watch a skilled worker… like watching a love affair between hands and material. Although I don't often have my hands on the material as such these days, I like to be there during much of the process and look over the shoulder of the maker, to be sure that what is in my head translates to the end result.

When shooting the film footage for the lenticulars, for example, I was there choreographing the model's moves, telling her to move her arm from the elbow not from the wrist, twisting and turning (poor girl!), discussing composition with the film director, Chris Springhall. It's fun, but also it's important… that you keep ownership over your project, so you need to be present. Additionally you learn the parameters of the medium and the other creatives you're working with. I learn a lot from watching other people work on collaborative projects, which equips me with information for future projects.

I think also my training helps my understanding of materials, processes and techniques. My education was very 'hands on', and I learned to understand materials and forms by playing with them. I was particularly into the positive and negative shapes in mould-making… how you can intervene with either copy and change the outcome. I played a lot with alginate (the non-toxic stuff dentists use) and cast the inside of my nostril, inside my ear, my mouth and my eyeball, not to mention numerous fellow students' toes. Odd when I think back, but I guess it was all part of understanding form. But now I design and direct more than make.

**Fashion / Flux / Flesh**
Christopher Breward

Like fashion, the primary function of jewellery is surely presentational—
designed to fit the body up for display; punctuating its surfaces to
emphasize form; insinuating itself into the spaces between skin and
the wider environment. And yet, as Naomi Filmer's work so deftly
demonstrates, the jeweller is perhaps freer to amplify fashion's sublime
ephemerality—its inbuilt tendency towards entropy, than the clothing
designer who is constrained by the cyclical dictates of fashionability.
It is perhaps no coincidence then that Filmer has taken up the practice
and metaphor of the 'lenticular'—a distancing means of interspersing
multiple perspectives that open up the body and its adornment to a
more fluid interpretation. In a similar way her ice and chocolate pieces
provide an achingly fleeting commentary on fashion and flesh as fluxive
properties. There is a delicious tension between these melting objects
and their almost synaesthetic layering of cool and warm sensations that
leads us directly to the extraordinary pleasures and disturbances caused
by the everyday act of self-fashioning. Dressing is a vital aspect of living,
yet it is also imbued with profound ambiguities. Filmer's work suggests
this with quiet eloquence, and in true *memento mori* style, she reminds
us how fragile and ephemeral such vanities are.

**Naomi Filmer**
*Lenticular Series 1,*
featuring *Ball Back* for
Alexander McQueen, 2006
Animated integral image,
produced by Create 3D
and BluLoop

**Naomi Filmer**
*Sketches*, 1993
Pencil

**Out of the Ordinary: Spectacular Craft**

# Lu Shengzhong

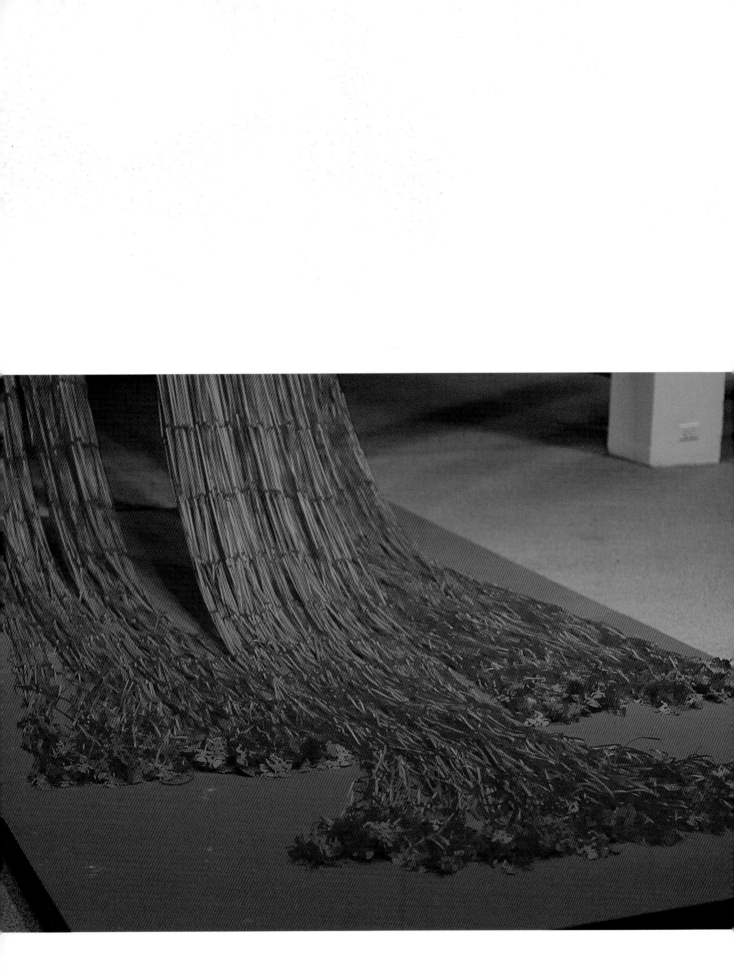

Out of the Ordinary: Spectacular Craft

# Lu Shengzhong
## Wu Hung

From *First Encounter: Lu Shengzhong,* originally published in New York, Chambers Fine Art, exhibition catalogue, 2000

Among a small group of contemporary Chinese artists who have obtained worldwide renown, Lu Shengzhong is unique in his quest to express individuality and contemporaneity through a Chinese vernacular art form—the art of paper cutting. While the other artists in this group all derive their idioms from elite traditions, whether traditional ink painting or Western conceptual art, Lu Shengzhong has been insisting on rediscovering the potential of a folk art tradition that is associated mainly with illiterate peasant women. On the other hand, his quest also has little to do with the Maoist doctrine of creating art for the masses by adopting grassroots styles, because his reinterpretation of paper cutting is highly individualistic and aims to express his personal understanding of some fundamental human values.

This unique position explains Lu Shengzhong's self-imposed solitude over the past fifteen years. His first major exhibition in 1988 transformed China's National Art Gallery into a temple filled with totem-like images, footprints suspended in mid-air, and silhouette patterns accompanied by illegible writing. The grand spectacle of this exhibition astonished Beijing's art critics, but Lu Shengzhong sensed no victory and kept describing his art as 'a lonely struggle along a desolate path'. In a longer explanation of this exhibition he wrote:

Previous spread
Lu Shengzhong's studio
in Beijing, China, 2006

**Lu Shengzhong**
*The Book of Humanity:
The Empty Book*, 2005
Paper-cut, glass, metal screws,
Chinese traditionally bound
books, installation
view at University Art
Museum, Albany NY

Exerting the utmost strength I squeeze out of a marketplace filled with contentious crowds, and find a silent, forgotten little path to walk on. Intrigued by unfamiliarity and longing, I follow it to retrieve original characteristics of humankind that have been filtered out by civilization, to summon images of lost souls in the polluted air, to understand the spiritual pursuit of mankind in its infancy, and to search for the deep connections linking my native land with the rest of the world. All my effort is to nourish the empty, worn heart of modern man with the unspoiled blood of an ancient culture. Thus suddenly I gain confidence, because in my mind I have paved a spiritual path for today's art.

Since then, Lu Shengzhong has been following this artistic path. He has also travelled to many countries to stage shows large and small.

Lu Shengzhong is interested in the dynamic life cycle of paper cutting: an old technique which sustains its vitality through endless re-creation and variation. Anyone familiar with Chinese paper cutting knows that the essence of this art lies in its constant renewal. Year after year, remaking paper cuts at holidays and festivals, weddings and funerals marks the passage of time and punctuates people's lives. Some basic elements in Lu Shengzhong's art also intimate what he has found most essential to the art of paper cutting. The first element is the dynamic relationship between positive and negative forms, which are always created simultaneously in the making of a paper cut. To Lu Shengzhong, the significance of this art never resides in either the positive or negative image alone, but must be realized through these two forms together, which come from a single piece of paper and are always linked in a conceptual whole. The relationship between these two forms offers him an ontological model enriched by countless metaphors: the body and the soul, image and text, dark and light, substance and emptiness, yin and yang. These various conceptual and metaphorical associations then become the 'themes' of his various projects.

The second basic element in Lu Shengzhong's art is related to the materiality of paper cutting. First, this art always generates tension between two-dimensionality and three-dimensionality: although a seemingly weightless paper cut is easily conceived as 'two-dimensional', it differs essentially from a painted image adhering to a flat surface. No matter how thin a paper cut is, it still possesses a volume and still has a front and back. When Lu Shengzhong attaches a paper cut to a board or makes it freestanding on the ground, he associates it with painting and sculpture, respectively, yet always contests its relationship with these two art forms. Second, a paper cut is always imbued with a sense of fragility: it is ephemeral, vulnerable to fire, rips, and all sorts of natural and human disasters. Not coincidentally, we find that 'fragility' has often become the subject matter of Lu Shengzhong's work, expressed sometimes in displaying damaged images in an exhibition and sometimes in a voluntary destruction of his paper images.

The third and last basic element in Lu Shengzhong's art is the temporal, meditative nature of paper cutting. He has repeated many times in his writing a conversation he had with a peasant woman back in the mid-80s. When he asked her what she was thinking when making a paper cut, she told him: 'Nothing, there is really nothing in my mind.' In interpreting this answer, Lu Shengzhong approaches paper cutting as a creative process that involves little emotional urge or rational thinking. In fact, this process is so rudimentary and spontaneous that it can hardly be called 'creative': what the woman—and himself—do in making a paper cut is merely to release part of themselves into an essential visual form.

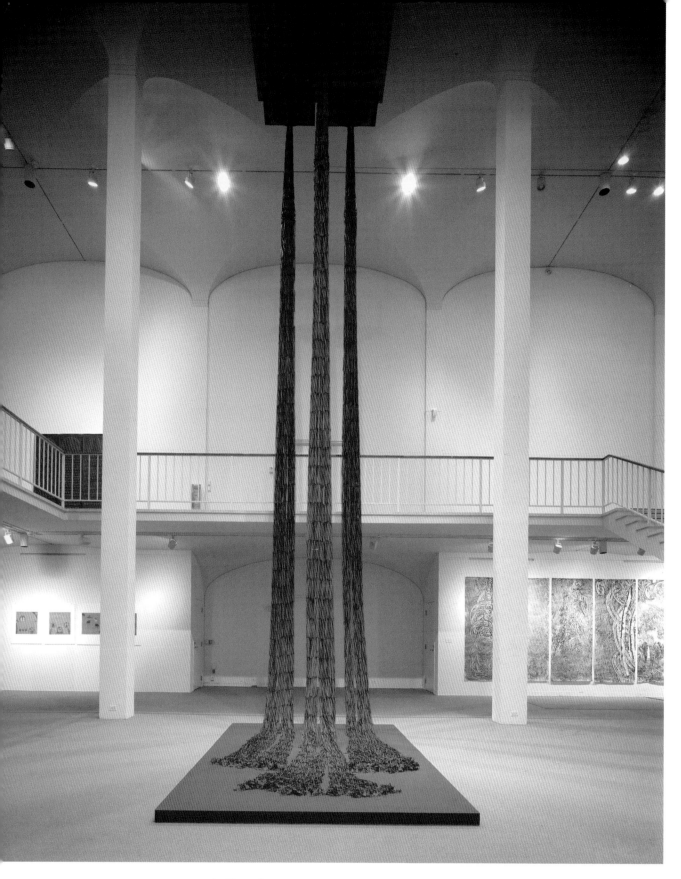

**Lu Shengzhong**
*The Book of Humanity: The Empty Book,* (detail) 2005
Paper-cut, glass, metal screws, Chinese traditionally bound books
Installation at University Art Museum, Albany, NY

**Lu Shengzhong**

93

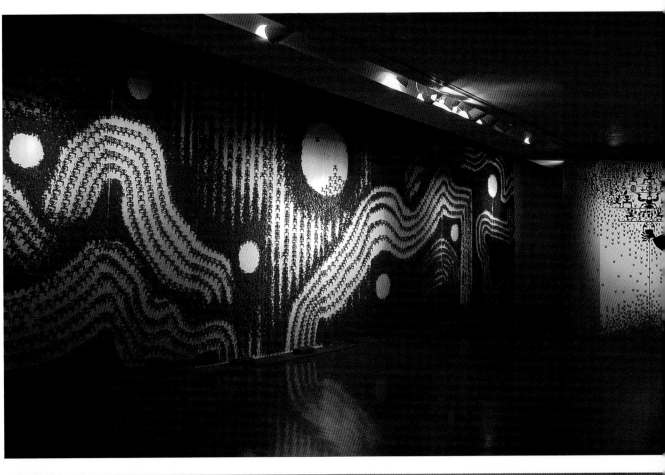

Out of the Ordinary: Spectacular Craft

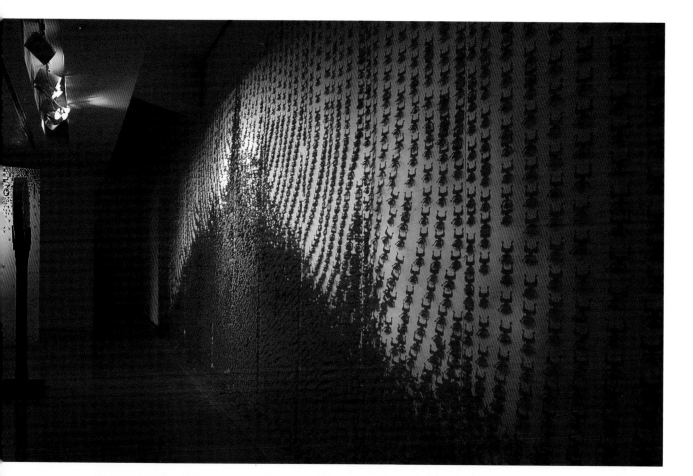

**Lu Shengzhong**
*The Book of Humanity:*
*The Empty Book*, (detail) 2005
Paper-cut, glass, metal screws, Chinese
traditionally bound books
Installation at University Art Museum, Albany NY

**Out of the Ordinary: Spectacular Craft**

**Lu Shengzhong in conversation with Laurie Britton Newell and Christopher Mao (translator)**
Beijing, October 2006

Previous spread
**Lu Shengzhong**
*The Realm of Great Peace*, 2003
Paper-cut, wood, string, glass
Installation at Eslite Gallery,
Taipei

**Lu Shengzhong**
*Boundary*, 2003
Bamboo, paper-cut and
other materials
Installation at Yiz Huang, Beijing

LBN  **In what ways is your work inspired by the ordinary?**

LS  My mother had a very skilled pair of hands. She made paper cuts, embroidered, drew floral decorations, decorated wedding rooms, cooked *mantou* [dough] when visiting relatives and did many other things. These are all beautiful details of everyday life. I was fascinated by it, and would participate. I lived in this kind of cultural environment. It is hard to separate folk art from the daily lives of ordinary people.

In the 1980s, I went to the countryside where folk art still existed, and did a lot of fieldwork. I was deeply moved by what I found and suddenly felt that in its essence art should be like this.

I am interested in the social aspects of folk art, it's very different to contemporary Chinese art, the major difference being that folk art is not for art's sake. It serves a purpose in everyday life.

During one of my trips to a rural area with a group of students we saw a beautiful embroidered cotton shoe insole, embroidered by a young girl. When the students saw how delicate and intricate this work was, they wanted to take photos and offered to buy it.

The young rural girl was very unhappy and said that the students were insulting her. This is because an embroidered insole is a form of engagement. Girls give this to their betrothed as a form of engagement like a ring, not to show anyone. The more worn it is the better, the happier the bride to be is. Traditional Chinese folk art is not like today's contemporary art because you are not supposed to hang it up and look at it. You are supposed to use it in your daily life, to feel it and to wear it. Today we talk about contemporary art as having a more spiritual function, but I think in comparison the foundations of folk art are much stronger, they are related to daily life, and the important things like life, birth, marriage....

There is a double side to me, one side artist, one side human being. If you were an artist twenty-four hours a day there would be problems! In order to be a good artist you have be an ordinary human being and be able to observe daily life, what surrounds you, and then find a way of representing it in your art.

LBN  **Why are your works handmade and not machine-made?**

LS   I am not against using a machine, but again for me what is more important is the actual process of cutting. The works may look the same but they are all different, not like machine-made products. There is much more humanity this way and each piece is unique. Also laser-cutting does not have the precision that hand-cutting has. With laser-cutting part of the paper is burnt away, so you don't end up with the negative and positive shapes. I would find this wasteful, having to lose one or the other.

LBN   **Can you tell me more about your relationship to your material?**
LS   I selected paper as my medium because the art is very delicate and not easy to keep. But for me what's more important is the spiritual connection, the process, than it being kept forever. I use this paper to cut this little red figure to demonstrate the delicate fragility of human beings. Ephemeral. A human's life is shorter than a paper's thickness. The material is not important. What is more important is the process you use to create that material, this is more valuable to me.

The paper is thin and fragile, using scissors I can cut four or five at one time, if I use a knife as much as twenty or thirty. When you fold it symmetrically, there is always a negative and positive imprint. The precision. You can trust this format, because it is exact. That's why I use paper, because it has an honesty and cannot lie.

**Lu Shengzhong**
Proposal for *Book of Humanity: The Empty Book,* 2005
Ink on paper

**Lu Shengzhong**

# YOSHIHIRO SUDA

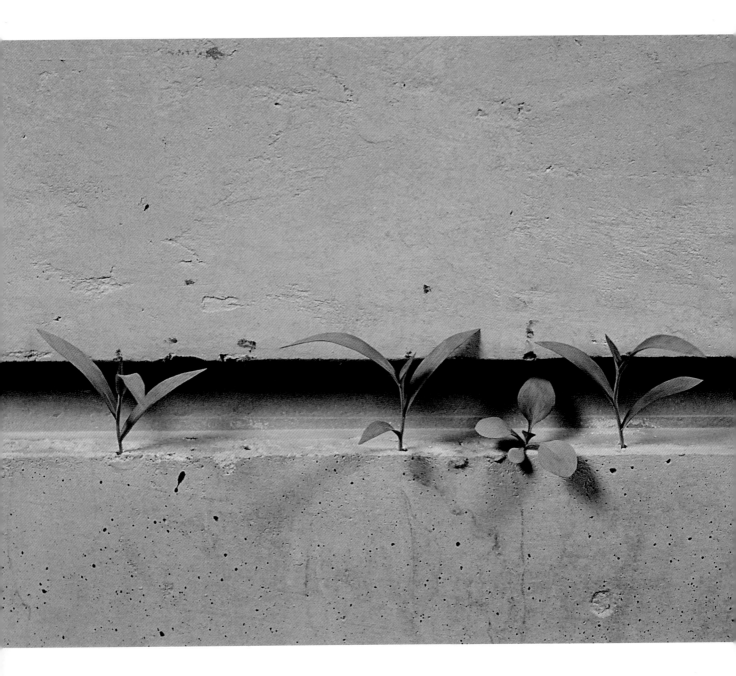

Out of the Ordinary: Spectacular Craft

**Yoshihiro Suda in conversation with Laurie Britton Newell and Toru Senso (translator)**

Tokyo, October 2006

Yoshihiro Suda works from his apartment in the Yanaka district of Tokyo, a low-rise residential area full of temples. When I visited him he was in the process of redecorating the flat. A beautiful wooden floor had recently been laid and Suda said that he was reluctant to varnish it, preferring to wait and see how it would warp with time. His studio is a modest-sized room with a workbench, a bookshelf and a large window that looks out over a balcony and neighbouring rooftops. Two weeds have poked themselves out between the balcony tiles. He works sitting in an office chair, the plastic armrests of which he has replaced with wood, preferring the feel of it. To the right of his bench planks of magnolia wood rest against the wall, to the left a large vice stands on the floor. Suda demonstrated his method for cutting wood using the vice. By pressing a sharp blade into a block and tightening the vice he is able to split the wood without disturbing the neighbours with banging. His carving tools are laid out on the desk, a small handsaw and a collection of different-sized chisels. Also on the table is an unpainted flower. The petals are paper-thin, and when you hold them up to the light they are almost translucent.

LBN **Why are you preoccupied with the ordinary?**

YS Probably because of my personality—I am interested in ordinary things, not only in my artistic life but also in my daily life. I like ordinary things, not the special or the particular. I want to feel their reality so it is from my life, the things that I can see with my eyes, through windows, while you're walking.

LBN **Do the particular types of weed that grow in some districts of Tokyo have a particular significance for you?**

YS I don't know many names of plants, like weeds on the ground, so I just give my works the title 'weed'. I don't signify special meanings, just the things that are generally there, that's what I make. It doesn't mean that the name of the plants has a particular meaning or something. Of course if I check in the botanical books, I can find out. But is it so important to know the 'what' of the weed?

LBN **Perhaps the opposite— it's more important that you don't, that they are anonymous…?**

YS I just find them in the street, and I think it's nice, and that's why I made it. Simply.

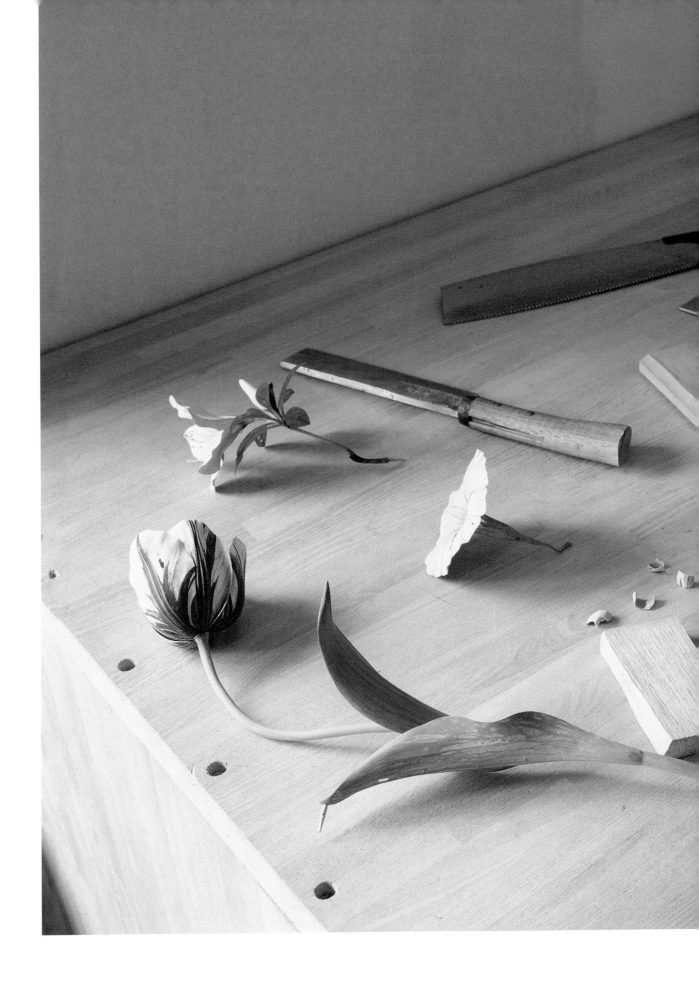

Out of the Ordinary: Spectacular Craft

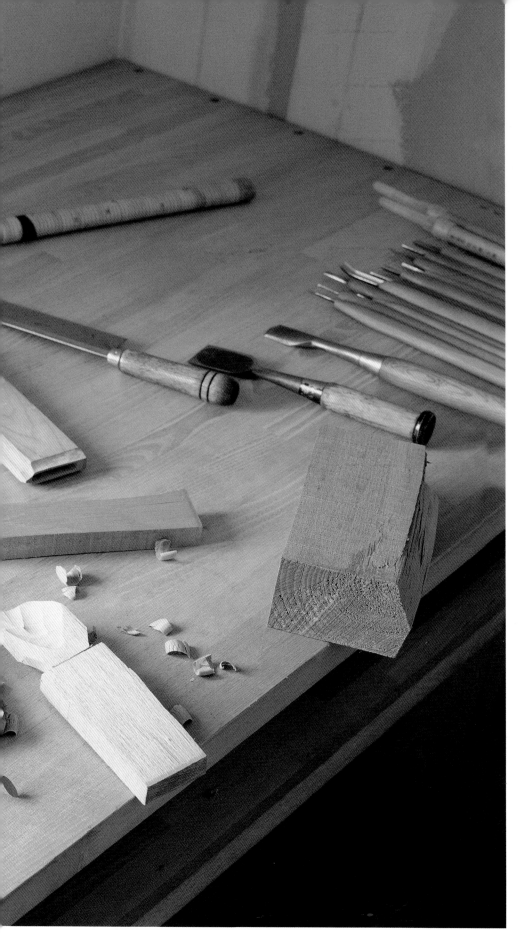

Yoshihiro Suda's workbench
in Tokyo, Japan, 2006

**Yoshihiro Suda**

LBN **Is your preoccupation anything to do with nature in the city, something natural growing in a very urban place?**

YS I'm interested in the plants growing in a town and city now because I'm living here now. Until I was 18 years old I was living in the mountains, in nature. But for me, for the subjects of my artworks I rather prefer the plants that grow in the city.

LBN **Could you talk me through your working process, from where you buy the wood all the way through to the end of the process?**

YS I buy Japanese magnolia wood as a log, from a wood store, and make 10 centimetre slices from it. Usually you leave it to dry for more that five years but if you slice it like this it dries much faster, and you can use it in two or three years.

LBN **Where do you dry it?**
YS In the flat.

LBN **Just up against the wall?**
YS No need to bring it to a particular place, I just leave it! As long as it is somewhere sheltered from the rain, it can dry naturally. After it is dry I cut it into blocks, as much as I want. Sometimes I use a knife or a machine. And then I carve. I don't draw anything on the wood, I just look at the blocks and start carving. I don't sketch. I just have the picture or the real thing in front of me and the block and start carving.

LBN **Do you use particular blocks of wood for particular plants because of the veins in the wood?**

YS I always use the same magnolia wood, so it doesn't matter what I'm making. Because of the grain of the wood, there is one direction that is easy to carve. But it is not the pattern of the design, as I will paint it afterwards so that you couldn't see it. So to choose the wood this is more a technical reason rather than a pattern.

LBN **So it's very different to the way you sculpt marble in terms of veins. Presumably you start with larger chisels and then get smaller and smaller for the fine work?**

YS My method is that I divide the piece into parts. For example, if it has six petals, I make each petal individually and I must finish each petal then combine them together with glue. I don't roughly finish the petals and then put them together. Your next question is how long it takes me to make this?

**Yoshihiro Suda**
*Lily*, 2006
Paint on wood
Installation at Städel Museum,
Frankfurt

**Yoshihiro Suda**

LBN **Yes!**

YS Probably four or five hours for one petal up to the same stage, probably two petals a day if I work a long day.

LBN **So all in all, for it to be finished and painted?**

YS Five days to a week for a flower but for a small weed maybe one or two days.

LBN **Now that I have seen your pieces with my own eyes, they are so well made, so perfect, they have stopped looking handmade. Why do you do all of this painstaking work to make something that is not obviously made by a human?**

YS Simply, I want to know how detailed I can make it, how real I can make it. This is the goal, the objective. This is an old-fashioned way of thinking, to make something that is so real that it looks like the original. It is not the fashion now, to observe something and make it very real, the idea itself is very deep. To make this kind of copy, the technique is very important. There are no goals as such, just the idea that I can make it better next time.

LBN **Is your work inspired by the traditions of _trompe l'oeil_ or still life?**

YS I don't think I am inspired by _trompe l'oeil_ but maybe you could say the idea is something similar. Often people think that my work may be in the _trompe l'oeil_ style. But actually my artwork includes the installation itself. Before I make artworks most of the time I will see the location, the location is very important—for example, I am not interested in putting my works on a display table, it is not interesting to me. In a museum or a gallery I like to see the space first as the location itself is also part of my artwork.

LBN **To an international audience what can be read as particularly Japanese about your work?**

YS I feel that my artworks are not strongly Japanese. The Japanese feeling of the work is in my attraction to traditional things, and their inherence in my work.

LBN **What about traditions of culture, or lifestyle?**

YS Not lifestyle, but cultural traditions: Japanese art, historic artworks such as _netsuke_. Not only in wood, but also painting.

**Yoshihiro Suda**
_Weeds_, 2004
Paint on wood
Installation at Palais de Tokyo, Paris

**Yoshihiro Suda**

LBN **You say it is as important where the work is installed, so you are interested in creating spectacle— an interesting combination of making something ordinary and everyday and the spectacle— a clash. What do you think?**

YS    Even though the scale of my work is small, if people find them, they can change people's feelings.... If you can take an interest in even the small things, it can change the atmosphere and the feeling of your surroundings. It makes you feel different from before.

LBN **There is an interesting combination of the real and the fictional—weeds don't really live in museums...**

YS    I don't intend to surprise. Mostly when I see a spot I like at the location then I decide what to put there, I don't have such a strong meaning in mind. I don't want to make people feel something like surprise, something against a place's natural feeling. That is not important.... I like people to smile when they find my work. That is what I want, to make people smile, as they would naturally. Not to try and teach them anything.

LBN **To get the joke— to understand it?**

YS    To relish it—yes... a very natural smile.

**Yoshihiro Suda**
*Weeds*, 2002
Paint on wood
Installation at Naoshima
Contemporary Art Museum

Yoshihiro Suda

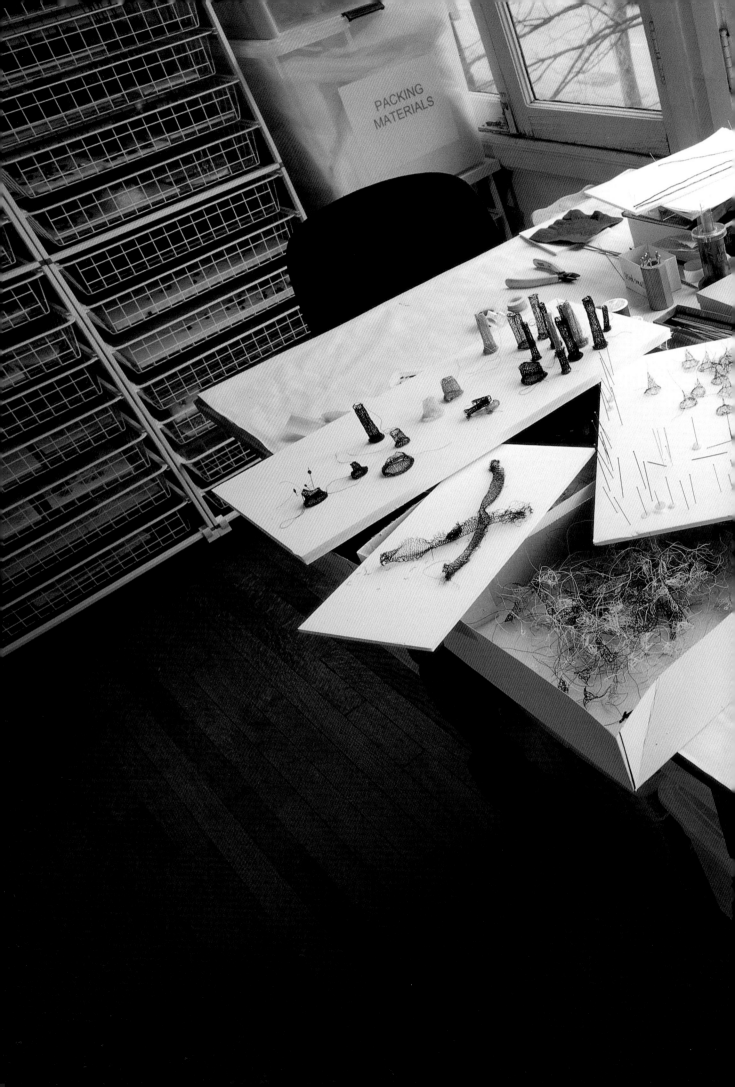

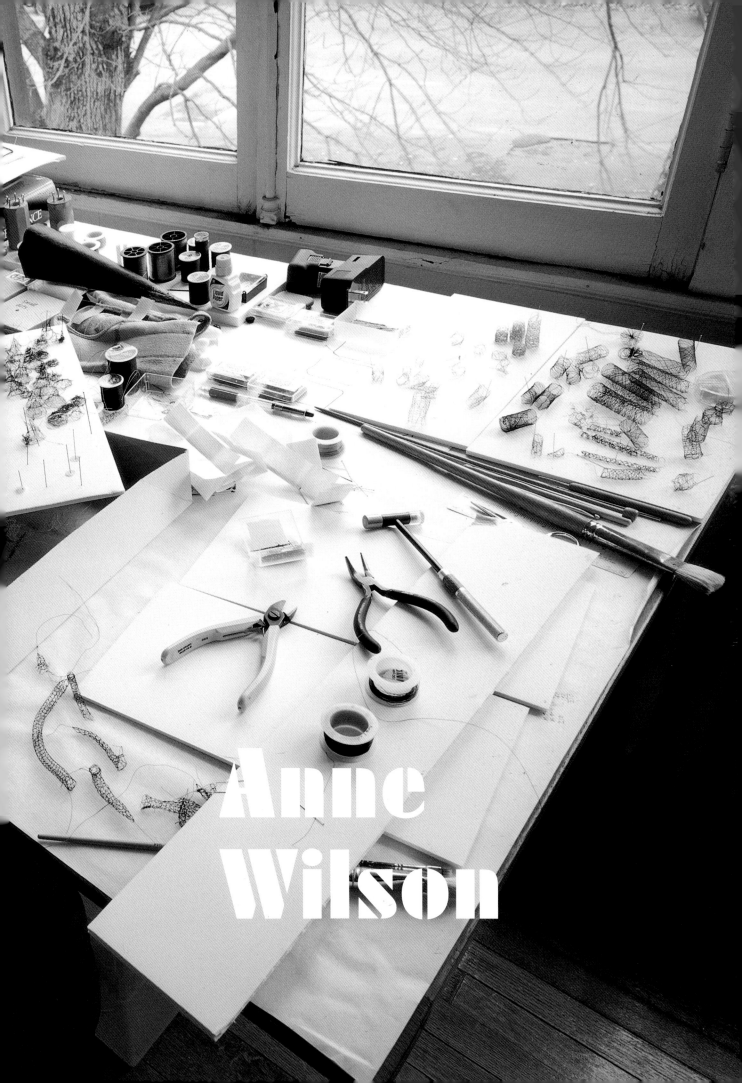

# Anne
# Wilson

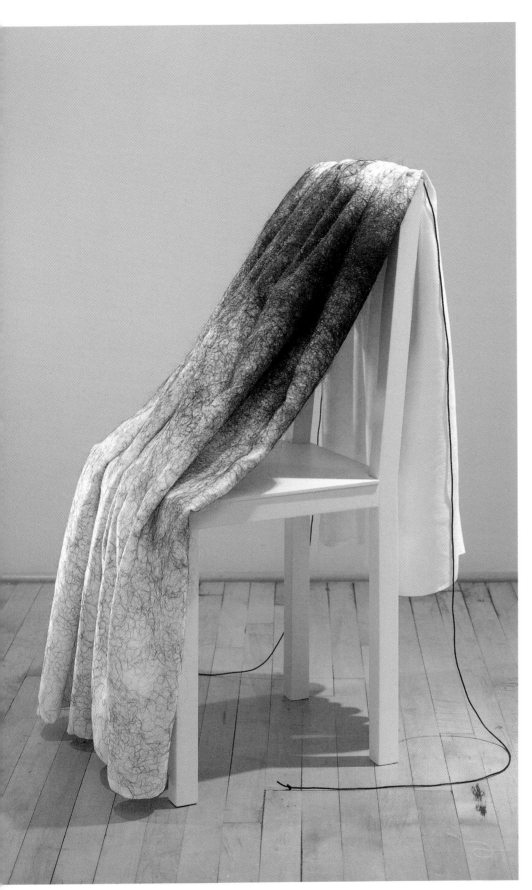

**Anne Wilson**
*Lost*, 1998
Found cloth, hair, thread,
leather cord, wooden chair

Out of the Ordinary: Spectacular Craft

**Anne Wilson in conversation with Laurie Britton Newell**
Chicago, November 2006

LBN **Can you tell me a bit more about your background and your influences?**

AW I was educated at a time (1970s) that was very influenced by at least five sort of paths or directions of inquiry concurrently, where no one path was dominant. For example, art history professors at graduate school at California College of the Arts [CCA] asked us to read Clement Greenberg, high modernism, from New York primarily—Western modernism. And we were looking at the works of Claes Oldenberg and Robert Rauschenberg and Robert Morris and Eva Hesse and Christo and the soft malleable materials that were being introduced into contemporary art. And so that's one path.

The second one was the newly emerging alignment of textiles to feminist concerns. Although I was in northern California and the Judy Chicago crew and *Womanhouse* [a women-only art event of 1972] were in LA, I think a lot of us were interested in opening up the alignments between textiles and women's issues in different ways.

The third influence is what I broadly would call multiculturalism— the way in which art history in general was being deconstructed and rethought, and looking at non-Western traditions of art making as valuable and valid. A larger global interdisciplinary contemporary art discourse was emerging. I studied textile history with Gerhardt Knodel at Cranbrook as an undergraduate and with Dr Ruth Boyer at CCA as a graduate. From both these teachers I learned to see art within cultural contexts. Also, the west coast of this country was quite a crossroads for textiles coming in from South America, Mexico and Asia, so I was around that material a lot. It had a tremendous impact, even to the point that I curated a couple shows of ethnographic textiles in San Francisco and taught textile history for a few years in Chicago before I realized I really wasn't an art historian and wanted to be an artist.

And then the fourth direction is the international art fabric movement, [the] works of Ritzi and Peter Jacobi from Germany, Magdalena Abakanowicz from Poland, Olga de Amaral from Colombia, Ed Rossbach and Lenore Tawney from the US among others. I mean, in the early 1970s Magdalena was making the most profound new art that I'd ever seen: these monumental, three-storey high, sisal woven walls that created spectacular installations and environments.

Previous spread
Anne Wilson's apartment
and studio in Evanston IL,
USA, 2006

**Anne Wilson**

So on the one hand there was Eva Hesse, who was more aligned with Postminimalism and recognized even in her own time as a mainstream contemporary artist, and artists of the early art fabric movement who never did quite merge effectively within the discourse of contemporary art history. These different paths were not necessarily talking much to each other.

I guess the fifth influence would be the Arte Povera movement from Italy and the way in which those artists were coming together around everydayness and the use of found things. I would say I was never much influenced by refined craft, or production craft, or trying to be a technical master. Those concerns had little to do with my training, and when you say 'craft' in this country that is often what others assume. But I am interested in the way in which the Arte Povera artists used the world of material things, and the way in which the histories of material everydayness were brought into the gallery and considered. Germano Celant, the theoretician of Arte Povera, came to Chicago and spoke many years ago. And I was very moved by what he said.

So where I am now as an artist is, in part, born out of these multiple histories.

LBN **In what way do you think your work engages with the idea of the spectacle of the everyday?**
AW     The accumulation of such a quantity of details creates a kind of *gestalt* [a configuration, pattern or organized field with properties that are perceived as greater than the sum of its component parts] which can be likened to the experience of spectacle. Just the array, the sheer quantity of the array. Also, in some of my work, you get the perspective of looking across, the raking view, which I align with Barry Le Va and other Postminimalist work. I've been interested in reading Rosalind Krauss on the topic of horizontality. In any case the level of detail, very small parts accumulated such that there are hundreds of them amassed, creates a kind of spectacle. Does that make sense in relation to your use of the term? And yet what the parts are made of and how they are made are often aligned with very familiar practices of the everyday— thread used to sew cloth together, fragments of the cloth itself, bits of wire that are used for a variety of practical purposes, or lace that may be part of a garment or home furnishing. These things all have a degree of familiarity, and the processes used to make them or take them apart come out of a cultural realm rather than an art realm. I think of much of my work as a conjunction between fine art and material culture where the histories embedded in found materials and processes are critical to the content of the work.

LBN **How do you like people to experience your work and engage with it? Do you think about your audience when you're making?**
AW     Yes. My exhibition in 2000 at the Museum of Contemporary Art in Chicago was primarily a body of work from the ten years prior that dealt with found domestic table linen and human hair. For a variety of reasons I made lots of work, different kinds of work, where the essential premise was the contradictory relationship between the formality and propriety of white table linen and the dirt and uncleanliness and abjectness of human hair when detached from the body—that's essentially the contradiction that made the work

**Anne Wilson**
*Hair Work*, 1991–3
Hair, thread, found cloth

art, and elicited contemplation. Some of this work was very disturbing to my audience, very disturbing—although initially I didn't fully understand this response. I did want the work to be evocative, but I didn't intentionally make it to be troublesome and disturbing. I realized that the response to any art has profoundly to do with one's own personal history. So if you are looking at artwork using human hair and you had family members who were in the Holocaust, your reaction to that work, just in the sheer nature of seeing hair detached from the body, could be completely different than that of an American-born hairdresser with no such family history. Somewhat in response to these discussions, I decided to make work for a period of time that involved other people. I made an interactive website called *Hairinquiry* which was really a research project, and that project is still on the Internet in an archived form. I also made a piece called *Told and Retold* which was a collaboration with media artist A.B. Forster where we took the responses from the website as told by the original contributor, or retold by another voice, and constructed a physical sound installation. Rather than moving away from the reactions that others felt about hair, I wanted to confront the issues and this involved bringing other people into the art process and working more socially and collaboratively in all regards. It was good learning for me.

LBN **You say that you are not interested in the mastery of a skill. But you have also talked about the idea of hyper-making. How does that work?**

AW    I go about making by using traditions that come out of craft histories, but I never studied, for example, traditional bobbin lace or worked in a textile factory—actually I have tried bobbin lace, but I'm terrible at it. It's more a matter of understanding the essential structure of a process and utilizing it in an art way, in a way that allows the viewer to align it with a cultural history and bring that history into the experience, but it's not about making a refined object from a process. A studio assistant, Lucas Cowan, and I once had a dare as to who could knit the finest—and the area of *Topologies* with the pins left in the knit structures was knit by Lucas using insect pins as the needles under a magnifier. He won the dare and I always called that an area of 'extreme craft'. So I've been introduced to many, many textile processes. Weaving I probably know best—I taught weaving at the Art Institute when I first came to Chicago. But in my art work the concept and content direct the use of material and process. I move from weaving to sound to glass to video and collaborative practices very liberally rather than being defined by a specific way of making. More constant is my interest in material histories and issues that come out of the everyday as they relate to our human condition.

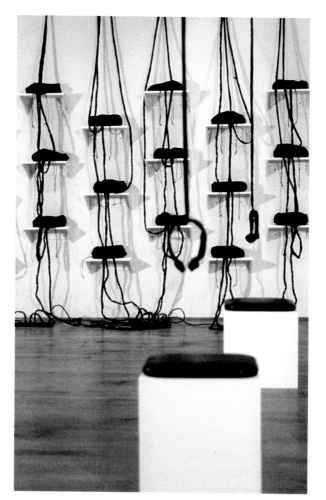

**Anne Wilson**
*Told & Retold: An Inquiry
About Hair*, 1998
Interactive sound installation;
collaboration with A.B. Forster

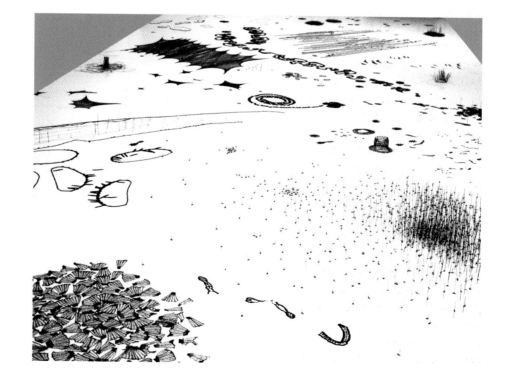

**Anne Wilson**
*Topologies* (detail),
2002–ongoing
Lace, thread, cloth, pins,
painted wood support

**Organic Landscapes:**
**Morphologies and Topologies in the Art of Anne Wilson**
Michael Batty

We live in an age where the organic analogy is all-powerful. A glance in the popular science section of any bookshop reveals our fascination with neo-Darwinism, with how biology makes the transition from the cell to the whole form and back. It is of little surprise—when digital computers are everywhere and the great centralized experiments of government in the twentieth century have been demolished—that our image of the world has moved from a system created top-down to one created from the bottom up. Cities are not planned but grow and sprawl, the economy holds itself together without central control, and the Internet is a network of networks whose growth and topology we are only beginning to understand using the new science of networks. Even our quest for good design is being challenged by those such as Richard Dawkins and Daniel Dennett who argue that slow, careful, tiny changes from the bottom up lead to systems whose biologies are optimally configured. 'Design by Nature' is fast becoming the paradigm for all design, certainly for good design.

Many of these themes run through Anne Wilson's art forms and sculptures. What is remarkable about the massive landscapes she builds is that they need to be understood on many different levels. The process Anne uses to conceive these landscapes is surely based on gradual and continuous conception and reconception of these forms. And the processes of 'making' these sculptures according to her templates can take up to ten days and can only be achieved using a team of artists who inevitably improvise a little on the standard sets of instructions that form the original idea. Each sculpture will differ each time it is made from the original template. When completed the art forms can be appreciated in many different ways and interpreted from a multitude of perspectives: through the way their materials—largely lace pieces and insect pins that root the structures to the landscape in which they are formed—have their own deep history whence these materials originate; through analogies with social and biological systems such as cities, social networks and cellular materials; but also through visual analogies where the focus is on pure form, such as constellations of galaxies, lily ponds, nets and routes, insect swarms and cell clusters. Anne's constructions are without intrinsic scale; they are scale-free, thus embodying elements of the emergent science of complexity and the geometry of chaos and fractals.

In the social sciences, there is a new cliché: to understand a system, you must be able to grow it. This is generative social science in much the same way that Anne Wilson's landscapes are generative art (in the loosest sense). This art cannot be understood without anticipating the way the artworks are originally conceived, the way they are made and constructed, and then the way they might be appreciated and interpreted and the contexts in which they are displayed. Her work has deep structure which excites a multitude of meanings.

Previous spread
**Anne Wilson**
*Errant Behaviors*, 2004
Video and sound installation,
edition of eight
Composer: Shaun Decker,
Animator: Cat Stolen,
Post-Production Animator and
Mastering: Daniel Torrente

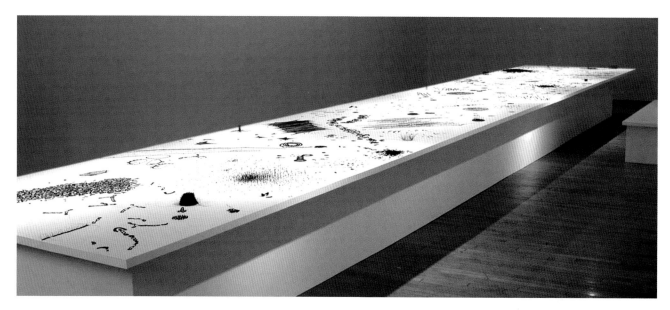

**Anne Wilson**
Overall view and details of
*Topologies*, 2002–ongoing
Lace, thread, cloth, pins,
painted wood support

**Anne Wilson**

121

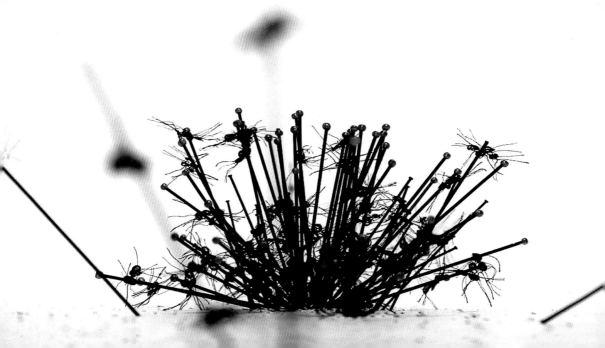

# LIZZIE
# FINN

How to...
Lizzie Finn

These images capture details from the working process of each of the artists featured in *Out of the Ordinary*. By selecting objects and tools from their studios, I've tried to provide some clues as to the particular processes they use to create their work. By focusing on each artist's hands doing things like carving, cutting, welding, sewing or drawing, I hope I can convey something of the magic surrounding the act of someone making something with their hands.

The images have been created by digitally tracing and composing photographs of the artists at work and then stitching the outlines onto lining fabric with other collage material. They became three-dimensional pieces which were then photographed, creating the series of two-dimensional images seen on the following pages.

I wanted these images to make reference to the 'How to' handicraft manuals of the 1970s. The purpose of these guides was to help anyone make something, demystifying the process. The power of the work from the selected artists, however, lies in the fact that only they could have created it. I like the idea that by contrasting these two completely different spheres of craft, the compositions have become deliberately misleading instructions of how to make the artists' work.

Out of the Ordinary: Spectacular Craft

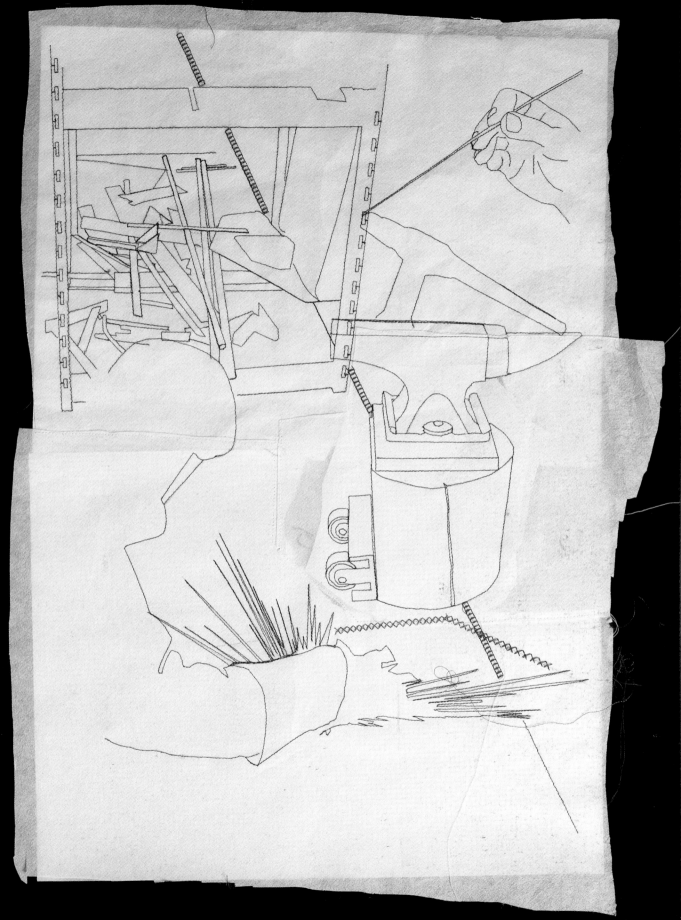

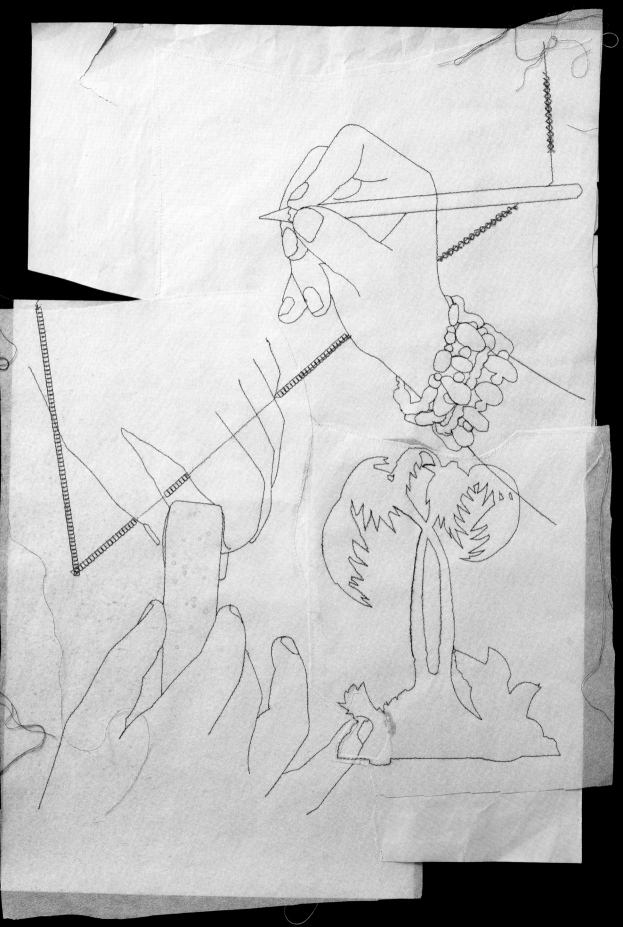

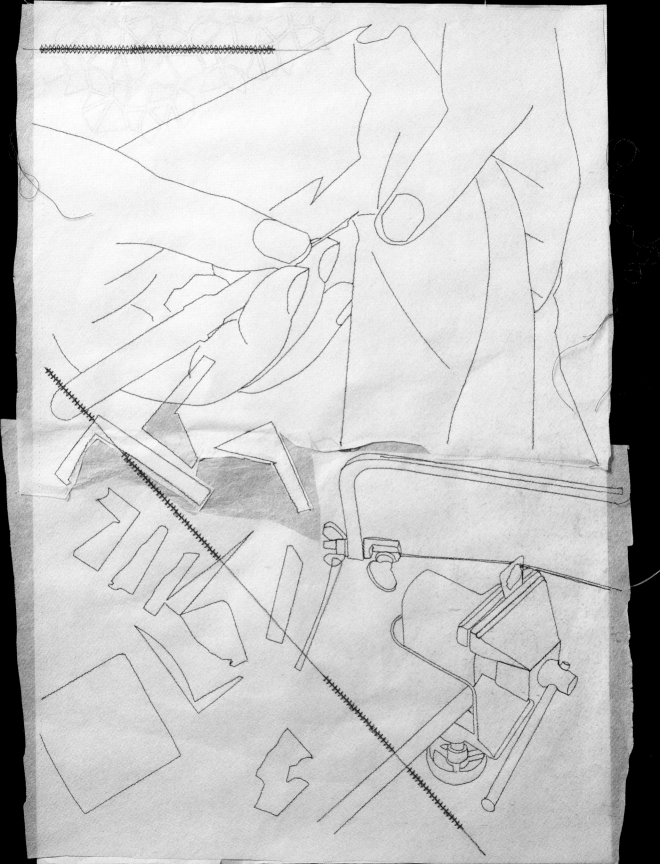

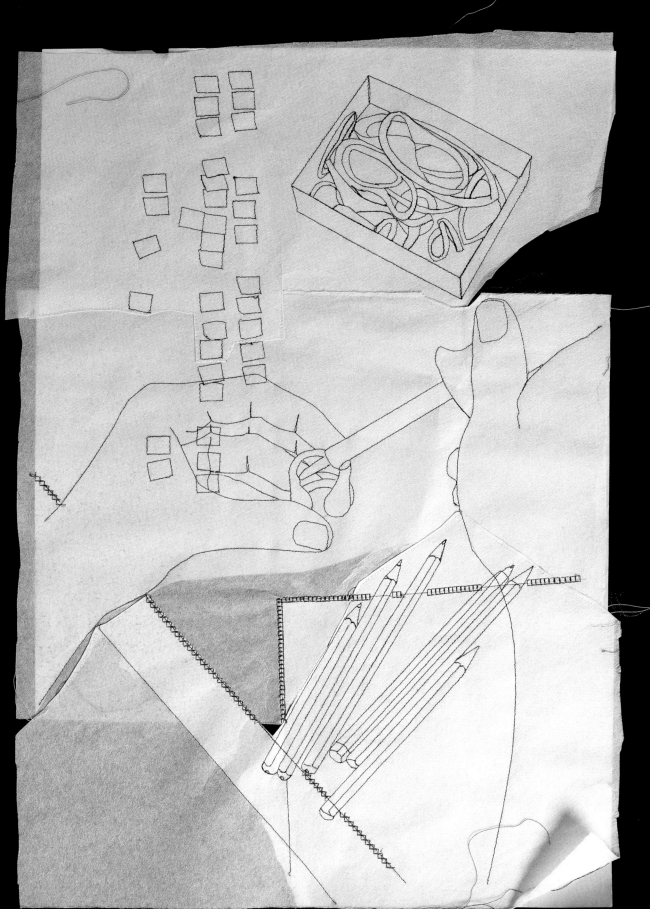

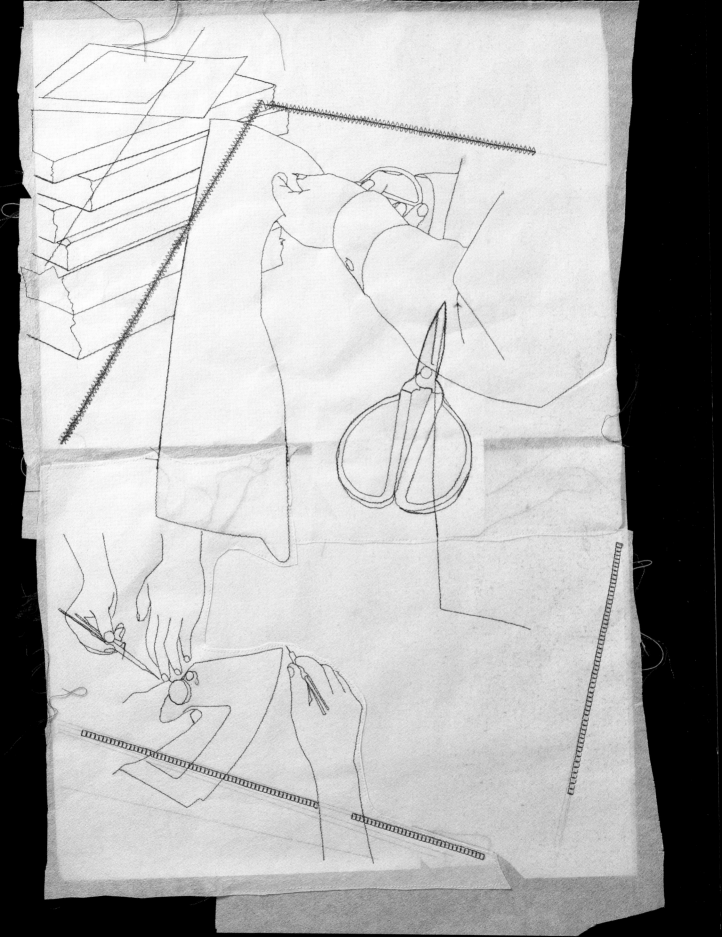

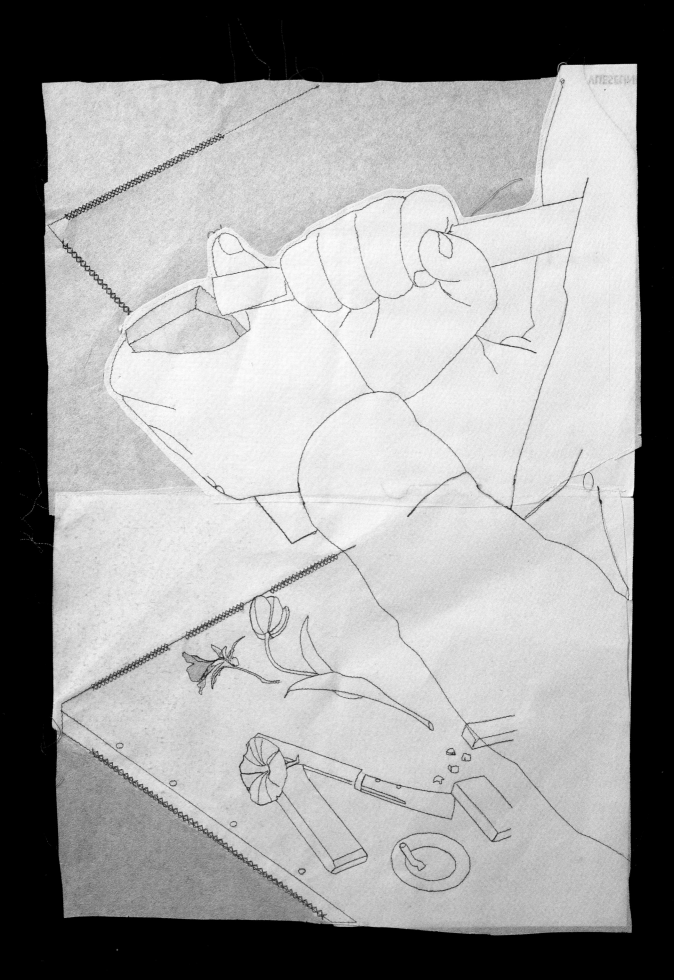

**Yoshihiro Suda by Lizzie Finn**

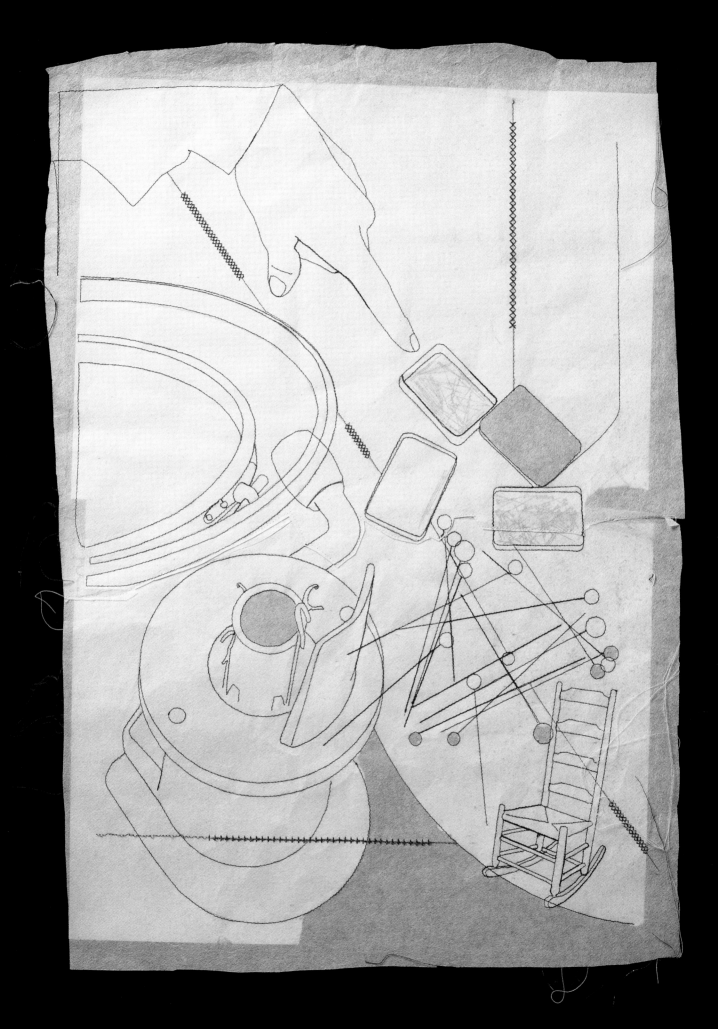

## Olu Amoda

1959 Born in Okere, Warri, Nigeria
1983 HND Sculpture, Auchi
Polytechnic, Auchi
1983 National Youth Service Corps
(NYSC), University of Lagos
1987–present
Teaching at Department of
Fine Art, Yaba College, Lagos

### Selected exhibitions and projects

Artist's Residency, Appalachian State University, Boone, North Carolina, 2006; *Design Made in Nigeria*, British Council project, Yaba College of Technology, Wotaside Studio, Lagos and Royal College of Art, London, 2006; *New Releases Objects of Art*, sponsored by Signature Art Gallery, Didi Museum, Lagos, 2005 (cat.); *Oscillating between the Ideal Form and Functional Necessities*, French Cultural Centre and Alliance Française of Abuja and Lagos, 2003–4 (cat.); *Laceration*, Nimbus Art Center, Lagos, 2003; *Forms of co-existence*, Intrafrika+: Africa meets South America meets Europe project, Goethe Institute, Berlin, 2003 (touring to Ghana, Togo, Senegal, Ivory Coast, Cameroon, Nigeria and Brazil)

### Selected publications, collections and awards

Onira Arts Africa, Ottawa, Canada; Delta State Honor for Innovative Sculpture, Lagos, 2006; French Embassy grant to attend Sixième Biennale de l'Art Africain Contemporain, Dakar, Senegal, 2004; La Fondation Blanchère grant to attend Ateliers de Sculpture Joucas, France, 2004

## Annie Cattrell

1962 Born in Glasgow
1984 BA Fine Art, Glasgow School of Art
1985 MA Fine Art, University of Ulster, Belfast
1999 MA Glass, Royal College of Art, London
2000 ACE Helen Chadwick Fellowship, Ruskin
School of Fine Art/British School in Rome/
Camden Arts Centre
2002 Leverhulme Artist in Residence,
Royal Institution of Great Britain
2005–present
AHRC Art, Science and Technology
Research Fellowship, De Montfort
University, Leicester
Currently teaching at Royal College of Art,
Wimbledon School of Art, Edinburgh
School of Art

### Selected exhibitions

*Arresting*, Anne Faggionato Gallery, London, 2006 (cat.); *Invisible Worlds*, Kunstverein Freiburg, Germany, 2006 (cat.); *Body Art & Science*, National Museum of Stockholm, 2005 (cat.); Museum für Gestaltung, Zurich, 2005 (cat.); *Sea*, Royal Scottish Academy, Edinburgh, 2005 (cat.); *From Within*, Faraday Museum Royal Institution of Great Britain 2005–present, London 2003 (cat.); *All or Nothing*, Berwick Gymnasium Gallery, Berwick upon Tweed, 2003 (cat.); *Head On (art with the brain in mind)* Science Museum, London, 2002; *British Art Group Show*, Allain le Gaulliard Gallery, Paris 2002; *Annie Cattrell*, Anne Faggionato Gallery, London, 2001; Werner Klein Gallery, Cologne 2001, *Psycho*, Anne Faggionato Gallery 2000

**Selected publications, collections and awards**
Aberdeen Art Gallery & Museum; City Art Centre, Edinburgh; Imperial College, London; Macmanus Art Gallery & Museum, Dundee; Centre for Life, Newcastle; Royal Institution, London; SmithKlein Beecham, London; Wellcome Trust, London; Stephen Webster, 'Art and Science Collaborations in the United Kingdom', *Nature Reviews Immunology*, vol.5 (December 2005), pp.965–9

**Represented by**
Anne Faggionato Gallery, London
www.anniecattrell.com

## Susan Collis

1956 Born in Edinburgh
2000 BA (Hons) Sculpture, Chelsea School of Art and Design, London
2000 MA Sculpture, Royal College of Art, London
Currently creates from a studio in Hackney, London

**Selected exhibitions**
*Until it makes sense*, SEVENTEEN, London and Galerie Thaddeus Ropac, Paris, 2006; *Thy Neighbour's Ox II*, Space Station 65 Gallery, London, 2005–6; *Arttextiles 3*, Bury St Edmunds Gallery and touring exhibition, 2005–6; *Chronic Epoch*, Beaconsfield Gallery, London, 2005; *Taking a line for a walk*, The Place, Letchworth, 2005; *The Vinyl Project*, Cork, 2005; *Drawing 200*, The Drawing Room, London, 2005; *I know all about you*, Aspex Gallery, Portsmouth, 2004 (cat.); *Free from the itch of desire*, Temple Bar Gallery, Dublin, 2004; *Emergency*, Aspex Gallery, Portsmouth, 2004; *40 White Chairs*, Wapping Hydraulic Power Station, London, 2003; *Engineer*, Beaconsfield Gallery, London, 2003

**Selected publications, collections and awards**
winner, 15th Oriel Mostyn Open, Wales, 2005; winner, Aspex Open *Emergency*, 2004; student winner, Jerwood Drawing Prize, 2002; student winner, £2,000 Pizza Express Prospects contemporary drawing student prize, 2002; Paul Smith (private collection); Shaun Monaghan (private collection); Paul Hedge, Hales Gallery; The Mag Collection of Image-based Art; The London Institute Collection; Tania Kovats (ed.), *The Drawing Book* (London, 2006); Jorunn Veiteberg, 'To be appreciated but not observed, reflections on a boiler suit', *Arttextiles 3*, Bury St Edmunds Gallery, 2005–6, pp.38–41

**Represented by**
SEVENTEEN, London

## Naomi Filmer

1969 Born in London
1991 BA (Hons) 3D Design: Wood, Metals &
      Plastics, Wolverhampton Polytechnic
1993 MA Goldsmithing: Metalwork & Jewellery,
      Royal College of Art, London
1994–present
      Lecturing on jewellery and fashion at
      Central St Martin's College of Art and
      Design, Royal College of Art, Middlesex
      University, University of Brighton, London
      School of Speech & Drama and Institute of
      European Design, Milan
2004 Research Fellowship, Central St Martin's
      College of Art and Design
2004–present
      Senior Research Fellowship at Central
      Saint Martin's College of Art and Design,
      London
      Currently a freelance jewellery designer,
      based in Milan

### Selected exhibitions and projects
*No Body Decoration, Lucca Preziosa 2006*, Le Art
Orafe Gallery, Lucca, Italy, 2006; *Touch Me*, V&A,
London, 2005; *Alchemy: Contemporary Jewellery
from Britain,* a British Council exhibition touring the
Middle East, 2007; *Spectres*, V&A, London, 2004–5;
*Malign Muses*, Mode Museum, Antwerp, 2004;
*Body Extensions*, Musée Bellerive, Zurich, 2004;
*Hometime Rooms*, British Council, China, 2003;
*Runway Rocks*, Swarovski, London, 2003; 'Chivas
Revolve', Seagrams, London, 2001–2; *Be-hind Be-
fore Be-yond*, Judith Clark Costume Gallery,
London, 1999; catwalk collaborations with Hussein
Chalayan 1994–6, Shelley Fox 1997, *The Watkins Era*,
Contemporary Applied Arts, 2005; Alexander
McQueen 2001

### Selected publications
Grace Lees-Maffei and Linda Sandino (eds.),
'Relationships between Design, Craft and Art',
*Journal of Design History*, vol.17, no.3 (2004);
Caroline Evans, *Fashion at the Edge* (New Haven/
London 2003); David Watkins, *Jewellery* (New
Holland, London, 1999); Andrew Tucker, *The
London Book of Fashion* (London, 1998); Derren
Gilhooley and Simon Costin, *Unclasped: A Book
of Contemporary British Jewellery* (London, 1997)

## Lu Shengzhong

1952 Born in Dayuji Village,
      Shandong
1978 BA Art, Shandong
      Normal University
1987 MA Fine Art, Department of Folk Arts,
      Central Academy of Fine Art, Beijing
Currently Professor in the Folk Art Department
      at Central Academy of Fine Art, Beijing

### Selected exhibitions
*The Book of Humanity,* Chambers Fine Art, New
York, 2004; *Cinesi artisti fra tradizione e presente*,
Marsilio Art Museum, Italy, 2004; *Auspice From
Above,* Eslite Gallery, Taipei, Taiwan, 2003;
*Guangzhou Triennial*, Guangzhou Museum of Fine
Art, Guangzhou, China, 2003; *Synthi-Scapes:
Chinese Pavilion of the 50th Venice Biennale*
(cancelled due to SARS), later shown in
Guangzhou Museum of Fine Art, Guangzhou,
China, 2003; *Openness, A la nuit tombée: Lu
Shengzhong*, Grenoble, France, 2002; *Lu
Shengzhong: World!*, Fukuoka Art Museum,
Fukuoka, Japan, 2001; *Beijing–Dachauer*, Dachauer
Schloss, Germany, 2001; *China: First Encounter*,
Chambers Fine Art, New York, 2000 (cat.); *Record
of Emotion, the Watchtower–Contemporary Art*
Beijing, 2000; *Gate of the Century (1979–1999)
Chinese Art Invitational Exhibition*, The
Contemporary Art Museum, Chengdu, 2000

### Selected publications
*Original Manuscript of Modeling* (SDX San Lian
Bookstore Publishing, Beijing, 2003); *Farewell
Tradition I* (SDX San Lian Bookstore Publishing,
Beijing, 2003); *Colored Clothes* (Guangxi Fine
Arts Publishing House, Guangxi, 2002); *Baby's
Gallus* (Guangxi Fine Arts Publishing House,
Guangxi, 2002); *Farewell Tradition II* (SDX San
Lian Bookstore Publishing, Beijing, 2002); Lu
Shengzhong and Li Hongjun, *Flourmade tiger of
Langzhuang* (Taiwan Hansheng, 2001); *Walking
and Observing* (SDX San Lian Bookstore
Publishing, Beijing, 2001)

### Represented by
Chambers Fine Art, New York

## Yoshihiro Suda

1969 Born in Yamanashi, Japan
1992 BA Graphic Design, Tama Art
University, Tokyo
Currently wood carving in Tokyo

### Selected exhibitions
*Lotus of Wood*, Chung King Project, Los Angeles, 2006; *post_modelism*, Bergen Kunsthall, Bergen, 2006; Marugame Genichiro-Inokuma Museum of Contemporary Art, Kagawa 2006 and the National Museum of Contemporary Art, Osaka 2006; *The Elegance of Silence: Contemporary Art From East Asia*, Mori Art Museum, Tokyo, 2005; *Skulptur—Prekärer Realismus zwischen Melancholie und Komik*, Kunsthalle Wien, Vienna, 2004; *Yoshihiro Suda and Takehito Koganezawa: 'Ma'*, Douglas Hyde Gallery, Dublin, 2004; *Kokoro no arica*, Ludwig Museum—Museum of Contemporary Art, Budapest, 2003; *Purloines Nature*, Kawamura Memorial Museum of Art, Chiba, 2003; *Focus: Yoshihiro Suda*, The Art Institute of Chicago, 2003; *The Eye of The Beholder*, Dundee Contemporary Arts—DCA, Dundee, Scotland, 2002; *+ vrai que nature*, capc Musée d'art contemporain, Bordeaux, 2001; *La Biennale de Montréal*, Quebec, 2000

### Selected publications and collections
Hara Museum of Contemporary Art, Tokyo; Contemporary Art Museum of Naoshima; National Gallery of Canada, Ottawa; Neues Museum, Nuremberg, Germany; Sabine Schulze (ed.), *Gärten; Ordnung, Inspiration, Glück* (Städel Museum, Frankfurt/Main, exhibition cat., 2006); Akiko Kasuya (ed.), *Three individuals. Zon Ito, Hajime Imamura, Yoshihiro Suda* (The National Museum of Art Osaka, 2006); *Suda Yoshihiro*, Marugame Genichiro-Inokuma Museum of Contemporary Art, Kagawa, 2006; *Life/Art '05*, Shiseido Gallery, Tokyo 2005–6

### Represented by
Gallery Koyanagi, Tokyo; Wohnmaschine, Berlin; D'Amelio Terras, New York

## Anne Wilson

1949 Born in Detroit, Michigan
1972 BFA, Cranbrook Academy of Art, Bloomfield Hills, Michigan
1976 MFA, California College of the Arts, Oakland, California
1979–present
Professor and Chair, Department of Fiber and Material Studies, The School of the Art Institute of Chicago

### Selected exhibitions
*Radical Lace & Subversive Knitting*, Museum of Arts & Design, New York, 2007 (cat.); *Material Difference*, Chicago Cultural Center, 2006 (cat.); *Alternative Paradise*, 21st Century Museum of Contemporary Art, Kanazawa, Japan, 2005–6 (cat.); *Anne Wilson: Errant Behaviors*, Indiana University SoFA Gallery, Bloomington, Indiana, 2005 (cat.); *Perspectives 140: Anne Wilson*, Contemporary Arts Museum Houston, Texas, 2004 (cat.); *Soft Edge*, Museum of Contemporary Art, Chicago, 2004; *Artadia: Berlin*, Momentum Gallery, Berlin, 2004; *Anne Wilson: Drawings and Stills*, Roy Boyd Gallery, Chicago, 2004; *Anne Wilson: Colonies and Links*, Revolution Gallery, Detroit, 2003; *Anne Wilson: Unfoldings*, Bakalar Gallery of Mass Art, Boston, Massachusetts, 2002 and the University Art Gallery of San Diego State University, California, 2003 (cat.); *2002 Biennial Exhibition*, Whitney Museum of American Art, New York, 2002 (cat.); *Anne Wilson: Anatomy of Wear*, Museum of Contemporary Art, Chicago, 2000; *Told & Retold*, Textile Museum of Canada, Toronto, 1999 (cat.)

### Selected collections
21st Century Museum of Contemporary Art, Kanazawa, Japan; Metropolitan Museum of Art, New York; The Art Institute of Chicago; Museum of Contemporary Art, Chicago; Detroit Institute of Arts; Cranbrook Art Museum; Bloomfield Hills, Michigan; Racine Art Museum, Wisconsin; The M.H. De Young Memorial Museum, San Francisco

### Represented by
Rhona Hoffman Gallery, Chicago; Paul Kotula Projects, Detroit
www.annewilsonartist.com

**Laurie Britton Newell** is Curator of Contemporary Programmes at the V&A. She has a BA in History of Art from the University of East Anglia, and an MA in Curating Contemporary Design from Kingston University and the Design Museum, London. Recent exhibition projects at the V&A include *Spectres: When Fashion Turns Back* and *Import Export: Global Influences in Contemporary Design* (both 2005) and she has curated Friday Late View events such as the *Tiara Ball* and *Clay Rocks*, part of the *Craft Rocks* series.

**Glenn Adamson** is Head of Graduate Studies and Deputy Head of Research at the V&A. He holds a PhD in Art History from Yale University and writes widely on design history, focusing especially on the twentieth-century craft movement, industrial design, and English and American decorative arts during the seventeenth and eighteenth centuries. In 2003, Dr Adamson curated the exhibition *Industrial Strength Design: How Brooks Stevens Shaped Your World*, a definitive study of the Milwaukee industrial designer, and authored a book of the same title published by MIT Press. Currently he is undertaking the co-editorship of the new *Journal of Modern Craft* for Berg Publications, with Tanya Harrod and Edward S. Cooke, Jr. (Yale University).

**Tanya Harrod** trained as an art historian. She is the author of the prize-winning *The Crafts in Britain in the 20th Century* (Yale University Press, 1999) and contributes regularly to the *Burlington Magazine*, *Spectator*, *Crafts* and *Times Literary Supplement*. She is currently writing a biography of the potter Michael Cardew for Yale University Press and researching a broadly based study of the meaning of the handmade for Reaktion Books. Harrod is on the advisory panels of the *Journal of Design History*, *Burlington Magazine* and *Interpreting Ceramics* and is Advisor to the *Craft Lives Project* based at the National Sound Archive of the British Library.

**Lizzie Finn** is an illustrator from London. Her work successfully crosses the fields of art, design and textiles and has been featured in leading publications worldwide. Her clients have included bands Moloko and The Beta Band, Converse, Clarks, Stussy, Nokia, Orange, Channel 4, Vitra and UK clothing label Silas. Magazine commissions include work for *Dazed & Confused*, *Vogue* and *The New York Times*. She lectures in graphic design at Chelsea College of Art and Design and has exhibited in London, New York, Venice, Stockholm, Melbourne and Tokyo.

**Philip Sayer** has been working as a freelance photographer since 1969. He has contributed to many prestigious books and magazines such as *Crafts*, *Domus*, the *Observer Magazine* and *World of Interiors*, as well as working extensively for international corporations and graphic design consultants such as Reuters, Paul Smith and Pentagram. As one of a small group of journalists and designers he helped found *Blueprint* magazine in 1984. He has undertaken commissions from leading arts organizations including the National Gallery, Prado, Tate, Crafts Council, British Museum, Royal Academy and V&A.

**David T. Doris** is Assistant Professor of the History of Art at the University of Michigan, Ann Arbor. He received his PhD from Yale University in 2002, travelled to Nigeria as a Fulbright Scholar, and has held residential fellowships at the Center for Advanced Study of the Visual Arts, the Smithsonian Institution, and the Getty Research Institute. He is currently preparing a book on assemblages of waste objects constructed by Yoruba people in Nigeria to warn thieves of the consequences of their actions. The PhD dissertation on which the book is based received the Roy Sieber Memorial Award for Outstanding Dissertation in the History of African Art, presented by the Arts Council of the African Studies Association in 2004.

**Jonathan Hoskins** is a V&A Museum Technician, responsible for handling, installing and packing objects for temporary exhibitions and permanent galleries in the Museum. He has a BA (Hons) Wood, Metal, Ceramics and Plastics from the University of Brighton and is currently studying for a BA in Politics, Philosophy and History at Birkbeck, University of London.

**Christopher Breward** is Deputy Head of Research at the V&A and a Visiting Professor at the London College of Fashion, University of the Arts London. He has written widely on the history and theory of fashion: key publications include *Fashion* (Oxford University Press, 2003), *Fashioning London* (Berg, 2004) and *Swinging Sixties* (V&A Publications, 2006).

**Wu Hung** studied Art History at the Central Academy of Fine Art, Beijing and worked in the Departments of Painting and Calligraphy and the Department of Bronzes in the Palace Museum, Beijing between 1972 and 1978. He has double PhD degrees in Art History and Anthropology from Harvard University, where he became a tenured professor in 1994. He is currently the Harrie H. Vanderstappen Distinguished Service Professor of Art History at the University of Chicago and Director of the Centre for East Asian Art. He has written widely on contemporary Chinese art. His recent exhibitions include: *Between Past and Future* (2004) and *The Negotiation of Beauty* (2005).

**Michael Batty** is Bartlett Professor of Planning at University College London, where he directs the Centre for Advanced Spatial Analysis (CASA). His research, as reflected in his recent book *Cities and Complexity* (MIT Press, 2005), focuses on systematic ways in which cities grow and evolve, using new developments in dynamics and chaos.

# Acknowledgements

This book is published
to coincide with *Out of
the Ordinary: Spectacular
Craft* — A V&A and Crafts
Council exhibition.

I am grateful to all of the
artists, contributors and
galleries who generously
shared their time, information,
ideas and images for the
catalogue. I would also like
to thank the following people
who made *Out of the Ordinary*
possible: Glenn Adamson,
Chloë Bird, Sara De Bondt,
Anjali Bulley, Mary Butler,
Annabelle Campbell (Crafts
Council), Lizzie Finn, Tanya
Harrod, Guillaume Olive,
Philip Sayer, Claire West
(Crafts Council), and especially
Alison Britton, Emiliano
Malferrari and Portia Ungley.

First published by
V&A Publications, 2007

V&A Publications
Victoria and Albert Museum
South Kensington
London SW7 2RL
www.vam.ac.uk

Distributed in North America
by Harry N. Abrams, Inc.,
New York

Paperback edition
ISBN 9781 851 775248
Library of Congress Control
Number: 2007924507

10 9 8 7 6 5 4 3 2 1
2011 2010 2009 2008 2007

Photography by Philip Sayer
Additional research by
Portia Ungley

Designer: Sara De Bondt
Copy Editor: Alison Effeny
Printed in Italy

*Out of the Ordinary: Spectacular
Craft* has been made possible
by the financial support and
curatorial assistance of the
Crafts Council

Registered Charity
Number 280956

## Picture Credits

All photography by Philip Sayer unless otherwise stated.

Additional illustrations on pp. 4, 8, 12, 28 and 125–31 by Lizzie Finn

**Inside front cover**
Anne Wilson, *Topologies* (detail from p.123)

**Introduction**
pp.10–11: Photographs by Laurie Britton Newell and Lizzie Finn

**The Spectacle of the Everyday**
pp.14, 17, 20: © V&A Images; p.19, pl.3: Courtesy of Susan Collis and SEVENTEEN; pl.4: © Yoshihiro Suda, courtesy Gallery Koyanagi, Tokyo; p.21, pl. 6: © Anne Wilson; p.22, pl.7: Photograph by Nicola Schwartz; pl.8: Photograph by Peter Cattrell; p.25, pl.10: Courtesy of Chambers Fine Art

**Technological Enchantment**
p.30: Private Collection; p.31: Courtesy of Phyllida Barlow; p.33: Collection of Ajay Bulley; p.34: Courtesy of York City Museum; p.36: Private Collection

**Olu Amoda**
pp.46–7: Collection Mrs K. Chellaram

**Annie Cattrell**
pp.54, 58, 61, 62–3: Photographs by Peter Cattrell; p.56: Photograph by Mark Pinder; p.57: Photograph by Michael Wolchover

**Susan Collis**
pp. 66, 74: Courtesy of Susan Collis and SEVENTEEN; p.68: Collection of Shaun Monaghan; p.72: Collection of Carl and Edwina Marks

**Naomi Filmer**
p.78: Produced by Create 3D and BluLoop; pp.81–2 Photographs by Nicola Schwartz; p.85: Produced by Create 3D and BluLoop

**Lu Shengzhong**
pp.90, 93, 94–5, 96, 99: Courtesy of Chambers Fine Art

**Yoshihiro Suda**
pp.102, 107, 109, 111: © Yoshihiro Suda, courtesy Gallery Koyanagi, Tokyo

**Anne Wilson**
p.114: Collection Lester Marks, Photograph by Tim Thayer; p.117: Collection Museum of Contemporary Art, Chicago, Photograph by Stephen Pitkin; p.119: First shown at Revolution Gallery in New York and Detroit, 1998 and at the Textile Museum of Canada Toronto, 1999; pp.120–21: Collection 21st Century Museum of Contemporary Art, Kanazawa, Japan, Lenore and Richard Niles, private collections.

**Inside back cover**
Olu Amoda, *Queen of the Night* (detail from pp.46–7)